IMAGES
of America

BREWING IN
SEATTLE

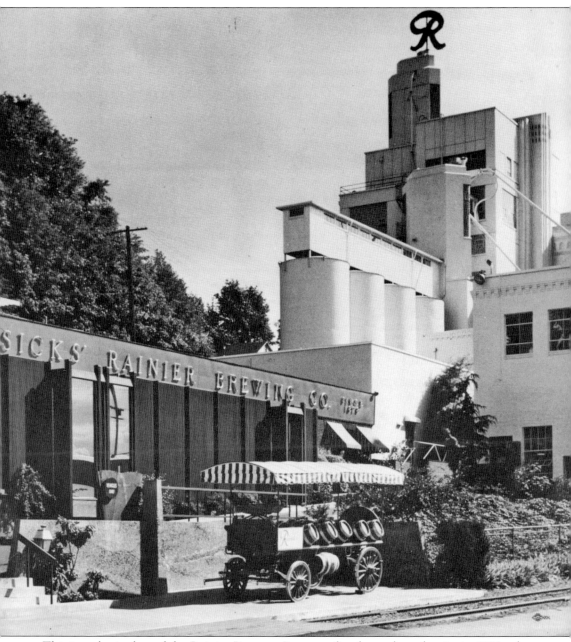

This is a classic shot of the Rainier Brewery. Beer was first brewed on the site in 1883, when Andrew Hemrich and John Kopp established their steam beer brewery. In 1933, shortly after the end of Prohibition, Emil Sick bought the old brewery to be the home of Rainier Beer for the next 65 years. (Seattle Public Library.)

ON THE COVER: Workers pitch casks of beer at the Seattle Brewing and Malting Company in 1914. With its flagship Rainier Beer, the brewery was once the sixth largest in the world. (Washington State Historical Society.)

IMAGES
of America

BREWING IN
SEATTLE

Kurt Stream

ARCADIA
PUBLISHING

Published by Arcadia Publishing
Charleston, South Carolina

Printed in the United States of America

Library of Congress Control Number: 2012934480

For all general information, please contact Arcadia Publishing:
Telephone 843-853-2070
Fax 843-853-0044
E-mail sales@arcadiapublishing.com
For customer service and orders:
Toll-Free 1-888-313-2665

Visit us on the Internet at www.arcadiapublishing.com

This book is dedicated to my wife, Gretchen. It is also for the blue-collar brewery workers at the old Rainier Brewing Company who clocked in each day and broke their backs to support their families and give generations of Northwesterns their Vitamin R. Thank you.

CONTENTS

Acknowledgments 6

Introduction 7

1. In the Beginning 9

2. The Rise of Rainier 23

3. Happy Days Are Here Again! 45

4. Emil Sick's Empire 53

5 The Wild Rainiers! 95

6. Redhook and the Rise of Craft Brewing 105

Afterword 127

ACKNOWLEDGMENTS

Thank you to my family for your love and support. Appreciation also goes to the following: Charles Finkel at Pike; Paul Shipman and Ben Wenter at Redhook; Terry Heckler at Heckler Associates; Gordon Ursaladdy; Ken House; Ben, Pam, and Lee McAllister; and the staff at the Seattle Public Library; Triage Wines; Capital Newspapers; Mickey Rooney; Beanie Ferguson O'Neill; Michael Magnussen; Stan Sherstobitoff; and most importantly, my wife, Gretchen, who put up with me drinking beer on Friday nights and then researching its history on Saturday afternoon.

INTRODUCTION

Seattle. What a wonderful place to live and drink beer! Before discovering Seattle's rich brewing history, it is good to know a little about the history of beer in the United States and how it played a significant roll in its development. As early as the 1580s, the very first English and Dutch settlers in the country were already brewing a type of corn ale. Many early colonists only settled in areas where corn used for ale could be easily grown. Beer would be a major reason why the pilgrims established their colony in Plymouth and endured their long and miserable first winter. A journal entry from one of the Mayflower passages explains, "We could not now take time for further search . . . our victuals being much spent, especially our beer."

Ales were mostly produced on a domestic scale prior to the Industrial Revolution, with the majority coming from families that home brewed small batches of beer for their own consumption. Notable home brewers included many of America's founding fathers, including George Washington, Thomas Jefferson, and Benjamin Franklin. Starting in the 1850s, immigration from countries with strong beer cultures dramatically increased the demand for beer in America. Many German immigrants were experienced brewers who quickly started their own breweries once settled. Technological advances were also a major factor in the expansion of the industry. Mechanical refrigeration aided in the production and storage of beer, while the invent of pasteurization allowed beer to be bottled, better transported, and have an extended shelf life. Thermometers and hydrometers also allowed breweries to produce a more consistent and uniformed product. These developments pushed the number of breweries from 451 in 1850 to 1,200 just a decade later.

By 1873, there were 4,131 operating breweries in the United States. It was the country's high watermark as far as the sheer number of breweries. (Even with the craft brewery boom of the past decade, there are currently just over 2,000 operating breweries in the United States.) Because it was impractical to ship beer over long distances, most of these breweries were small, independently owned, and catered to their local community. Each town had a number of these small breweries, each handcrafting beer in small batches. As technology and big business grew, almost all of these breweries disappeared. A little over 100 years later in 1983, the top six breweries (Anheuser-Busch, Miller, Heileman, Stroh, Coors, and Pabst) controlled 92 percent of US beer production.

Seattle's early brewing history is a bit confusing. Many of the early breweries changed names and owners multiple times in their short existences. There was a multitude of brewery consolidations throughout the city's history as well, sometimes creating new breweries but also ending others. Most confusing (even to many local historians) is the history of Seattle's most recognized beer, Rainier. Today, there are two large breweries still standing in south Seattle that once brewed Rainier. One brewed Rainier from 1893 to 1916, and the other brewed it from 1934 to 1999. The first was the Seattle Brewing and Malting Company's mammoth brewery in Georgetown. In 1893, the Bay View Brewing Company consolidated with the Albert Braun Brewing Company and the Claussen-Sweeney Brewing Company. The new entity, known as the Seattle Brewing and Malting Company, started with a capital stock of $1 million. It was decided that the company would use the larger Sweeney brewery in Georgetown as its main production plant while continuing to use the Bay View Brewery for secondary support. The company's first beer, Rainier, quickly became a sales phenomenon. Within 10 years, the Seattle Brewing and Malting Company became the largest brewery west of the Mississippi and eventually became the sixth largest in the world. The company's extraordinary growth was also made possible by the company's investment in the latest transportation and packaging technology. The Georgetown brewery expanded into the size of three city blocks, becoming the single largest industrial institution in the state. It very well could have become the largest brewery in the United States, but thanks to the Noble Experiment, we will never know. Prohibition started in Washington State in 1916, four years before it was enacted

nationally. Believing the ban would not spread to California, the Seattle Brewing and Malting Company moved its operations to San Francisco. It was the last time that true Rainier Beer was brewed in the Georgetown brewery.

Emil Sick came to Seattle in 1933, shortly after Prohibition's end. Sick and his father already owned a series of successful Canadian breweries and were eager to enter the post-Prohibition US beer market. Sick remodeled the old Bay View Brewery, located two miles north of where Rainier was brewed prior to Prohibition. The following year, he leased the Rainier Beer trademark and began brewing the beer in Seattle for the first time in 18 years. Much like Seattle Brewing and Malting Company in the late 1800s, Sick found great success with Rainier Beer. The brewery also saw a number of large expansions, including the installation of the iconic letter *R* on its rooftop in 1954. The US brewing industry changed dramatically following World War II, and to survive, Rainier changed along with it. Massive consolidation and improved transportation technology ended the long-held domination of the independently owned regional brewery. It would be the beginning of the rise of the large, national breweries, such as Anheuser-Busch and Miller Brewing Company. In 1945, there were 468 breweries in United States, but by 1965, that number fell to 197. Realizing this trend and wanting to keep Rainier in the city he called home, Emil Sick sold 49 percent of Rainier Brewing Company stock to Molson Brewery, a company that, at the time, was one of the world's largest brewing companies and the oldest brewing firm in North America. With Molson's financial backing, Rainier further expanded into new markets and thrived as a regional brewery. In 1970, it was the 16th largest brewery in the country, producing up to 125,000 gallons of beer daily. As the industry continued to evolve towards national brewery company dominance, Rainier was sold again to Wisconsin-based G. Heileman Brewing Company in 1977, then the seventh largest brewing company in the United States. While under G. Heileman, the Rainier Brewery also started producing many of its other regional beers in Seattle, including Old Style, Mickey's, Lone Star, and Henry Weinhard. Heileman would be bought and sold a few times over the next 10 years. Finally, in 1996, G. Heileman was acquired by Stroh Brewing Company, and in 1999, after seeing substantial sales loses, Stroh dissolved its holdings, ending its 149 years of brewing. Pabst Brewing Company bought the Rainier brand and switched production to its Tumwater brewery. Sadly, it was the end of Seattle-brewed Rainier Beer, leaving most of the 230 brewery employees without a job. Today, Rainier is still widely available in the Seattle area but is brewed under contract in Irwindale, California.

But just as Seattle was saying goodbye to Rainier in 1999, an exciting new chapter in Seattle's brewing history was already starting to gain momentum. For over 40 years, Rainier was the only brewery in all of Seattle; however, today, there are more than 20. What began with Redhook in 1982 has exploded over the past 10 years and transformed the city into a craft beer destination. A new generation of knowledgeable beer drinkers has embraced the craft beer movement in not only Seattle, but in the entire Pacific Northwest. It has become a supportive community of beer enthusiasts who want quality and choice from their beer and understands the importance of a locally run small business. From the brewer to the bartender to the drinker, history is being made today. So as we all enjoy the many wonderful Seattle brewed beers (hopefully, you have one in your hand as you are reading this), let us forever remember the men and women from the past who dedicated their lives to Seattle-brewed beer. For without their efforts and dedication, brewing in Seattle would not be where it is today. *Prost!*

Author's note: Emil Sick's main Seattle brewery had a number of names over the years, including Century Brewing Company, Seattle Brewing Company (also the name of the pre-Prohibition brewer of Rainier), and Rainier Brewing Company. In order to elevate confusion, in most cases, the author will refer to Sick's brewery as the Rainier Brewing Company, regardless of the time frame.

One

IN THE BEGINNING

The schooner *Exact*, a small vessel carrying 10 adults and 12 children, landed on Alki Beach in the brisk November air in 1851. Known as the Denny party, they were the first white settlers to arrive in Seattle. That following spring, most of the party traveled the short distance across Elliott Bay and made their home on present-day Pioneer Square. The settlement was named Seattle. That same year, Henry Yesler joined the settlement and built a lumber mill, providing the town's principal economic support. By 1860, Seattle was the fastest growing city in the Washington Territory, with a population near 1,000 people. It was during this time that Antonio B. Rabbeson arrived in Seattle. While mostly a forgotten figure today, Rabbeson was a true Washington pioneer. His notorieties included being the territory's first mail carrier, the second sheriff in Lewis County's history, and one of the first elected members of the lower branch of the legislature in the Washington Territory. Of his civil and commercial accomplishments, owning a Seattle saloon likely ranked relatively low on his list of personal achievements. But in 1863, after growing tired of the quality and price of importing beer from other surrounding areas, Rabbeson went about building his own brewery. The following spring, Rabbeson's Washington Brewery advertised its porter, beer, and ale to the people of Seattle. He sold both the brewery and tavern the following year, but his brewery was Seattle's first and the start of the city's brewing tradition.

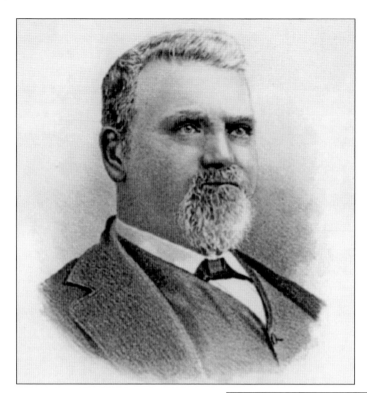

Pictured here is Antonio B. Rabbeson, born in 1825. He was the founder of Washington Brewery in 1863, Seattle's first brewery. He died in 1891. (Author's collection.)

The first brewery in Washington State was erected in Steilacoom by Martin Schmieg in 1858. Later, in 1865, he and his business partner Joseph Butterfield moved to Seattle and established the North Pacific Brewery, located on the west side of First Avenue at Columbia Street. This 1865 newspaper advertisement for the brewery appeared in the *Seattle Gazette*, the city's first newspaper. (Seattle Public Library.)

GOOD NEWS!

NORTH PACIFIC
BREWERY

JUST ESTABLISHED IN SEATTLE.

This magnificent Brewery having been completed is now manufacturing

PORTER, ALE
AND
LAGER BEER.

Which will be sold at the lowest cash prices.

Legal tenders taken at market value.

Give us a Call—try for yourselves!
BUTTERFIELD & CO.

Seattle, Feb. 1st 1865. no48-tf

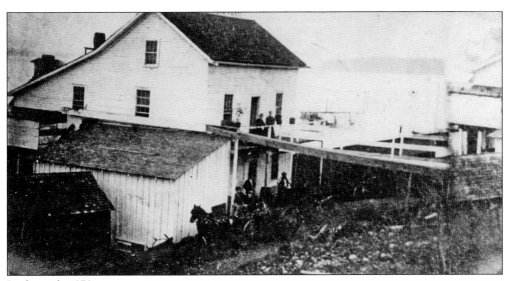

In the early 1870s, Schmieg left Seattle to visit Germany, leaving the North Pacific Brewery operations to manager August Mehlhorn. When Schmieg mysteriously never returned, Mehlhorn took the absentee owner to court for back wages and was eventually assigned sole proprietorship of the North Pacific Brewery. As Seattle continued to grow, the property became increasingly valuable. When the brewery was destroyed by a fire around 1875, Mehlhorn sold the property, jump-starting his career as a prominent Seattle businessman. Above is a photograph of the brewery from around 1865, and seen at right is an 1865 advertisement for the North Pacific Brewery. (Both, Seattle Public Library.)

North Pacific Brewery

Picht & Mehlhorn

SUCCESSORS TO

Martin Schmieg

Front Street, Seattle, W. T.

—

LAGER BEER AND PORTER.

SEATTLE BREWERY

Cor. Fourth and Mill Streets,

Seattle.

SLORAH & CO.

Proprietors.

BREWERS AND MALTSTERS

MANUFACTURERS OF

SUPERIOR LAGER BEER

AND

EXTRA FINE BOTTLED ALE AND PORTER.

Our Bottled Ale and Porter is equal, if not superior, to any foreign brand.

Seen here is an 1876 advertisement for the Seattle Brewery. Andrew Slorah first operated the Seattle Brewery on Fourth Avenue and Mill Street (later renamed Yesler Way). Slorah later relocated the brewery to Yale Avenue North, between Republican and Mercer Streets, in what is now the South Lake Union area of Seattle. The popular brewery was known to most people at the time as Slorah Brewery and was one of the first Seattle breweries to bottle its beer. (Seattle Public Library.)

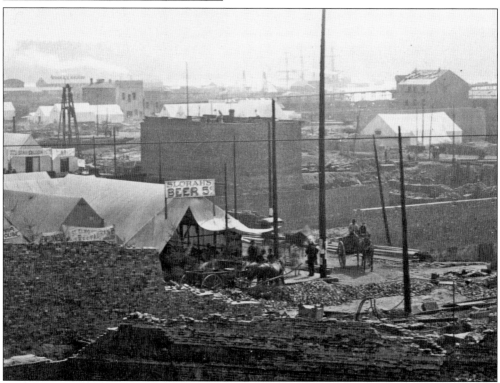

The Great Seattle Fire destroyed much of the city in June 1889. Immediately following the devastation, businesses reestablished themselves by erecting temporary tents. This photograph from 1889 shows Slorah's brewery selling its beer from one of the aforementioned tents for 5¢ a glass. Surely, this was a welcoming sight for a city suddenly forced to rebuild its core. (Seattle Public Library.)

Alvin Hemrich was born in Alma, Wisconsin, in 1870. After working in his family's breweries for a number of years, he would follow his older brother Andrew's footsteps and move to Seattle. There he purchased Slorah's brewery in 1897. A few years later, he was joined by Julius Damus and his brother Louis to form the Hemrich Bros. Brewing Co. The Hemrich family was soon to be the heart of the Seattle beer industry. (Author's collection.)

A photograph of the Hemrich Bros.'s brewery as it stood in 1900 is below. By 1906, the brewery grew to an impressive annual production of 30,000 barrels. Its principal beers were called Apollo and Select Beer. (Author's collection.)

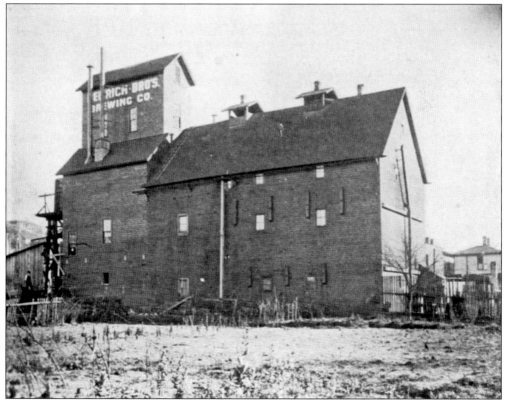

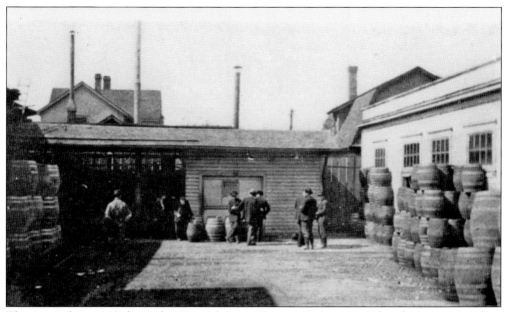

This image from 1907 shows the Hemrich Bros. Brewing Co.'s open-air keg drying space. Alvin Hemrich operated the company, alongside his family's other successful Seattle breweries, up until Prohibition. (Stan Sherstobitoff.)

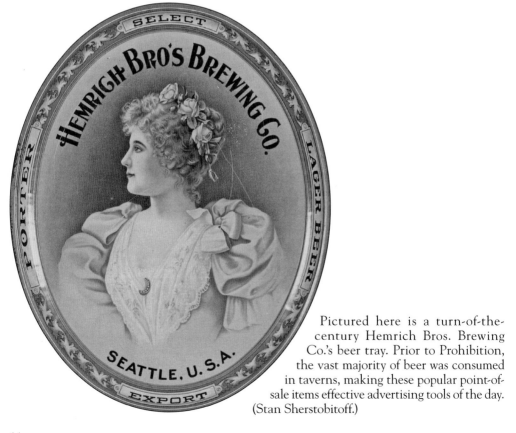

Pictured here is a turn-of-the-century Hemrich Bros. Brewing Co.'s beer tray. Prior to Prohibition, the vast majority of beer was consumed in taverns, making these popular point-of-sale items effective advertising tools of the day. (Stan Sherstobitoff.)

Andrew Hemrich was born in Alma, Wisconsin, in 1856 and first started working at his father's brewery at the age of 10. In 1883, he came to Seattle and formed a copartnership with John Kopp. Together they started the Kopp & Hemrich Company and built a small steam-beer brewery. The brewery eventually evolved into the Rainier Brewery. This cartoon of Hemrich was featured in the 1906 book *Cartoons and Caricatures of Seattle Citizens* and was illustrated by Ernest Jenner. (Author's collection.)

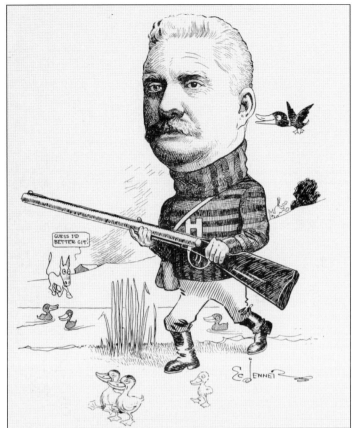

The Kopp & Hemrich Company saw immediate success. In its first year, it sold more then 2,600 barrels of beer. This picture shows the early stages of the brewery in 1880. (Seattle Public Library.)

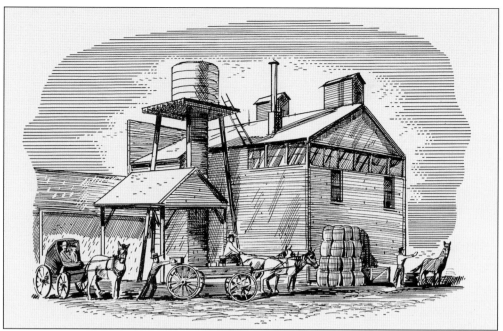

Seen here is an artist rendering of the Bay View Brewery as it appeared around 1880. Two years later, Hemrich bought out Kopp's shares of the brewery and was joined by his father, John Hemrich, and brother in-law Frederick Kirschner. The brewery then reorganized under the name Bay View Brewing Company. (Seattle Public Library)

The Bay View Brewery was built on the edge of tidelands formed by the Duwamish River delta in an area that is now the SoDo neighborhood of Seattle. The tidelands were eventually filled, and the Duwamish River was dredged and straightened. The tidelands are shown in this 1901 photograph along with part of the Bay View Brewery on the lower right-hand side. (University of Washington [UW] Special Collections.)

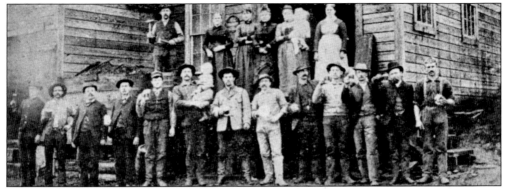

Bay View Brewery workers pose for this 1888 photograph. As more people settled in the Seattle area, the Bay View Brewing Company continued to make additions to increase its production. In 1890, sales of beer increased by a whopping 33 percent over the prior year in the state of Washington. (Stan Sherstobitoff.)

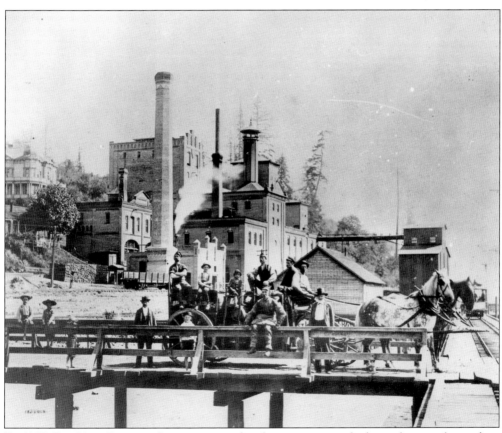

By 1887, Bay View Brewing Company completed construction of a larger brewery located on the same site. They were now Seattle's biggest brewery. This image shows workers in front of the brewery on the Grant Street Bridge in 1898. The bridge was demolished a few years later as the tidelands were filled. (Seattle Public Library.)

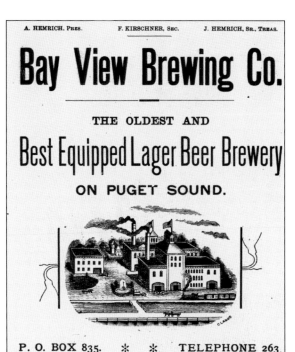

The Bay View Brewing Company consolidated into the Seattle Brewing and Malting Company in 1893 but continued to be used as a secondary plant by the company. In 1908, it was still producing over 80,000 barrels a year. Production continued until 1913. When statewide Prohibition became law in 1916, the brewery was used as a flour mill for the next 14 years before again becoming a brewery under Emil Sick. At right is an 1891 advertisement for the brewery. (Seattle Public Library.)

First known as the Spellmire Brewing Company, Washington Brewing Company operated from 1902 to 1915 and originally focused on British-style ales. This photograph, taken around 1913, shows Washington Brewing Company driver John James Hayes with the brewery's Mack truck, reported to be the first Mack truck in Seattle. (Author's collection.)

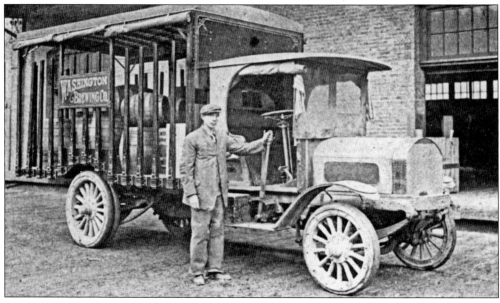

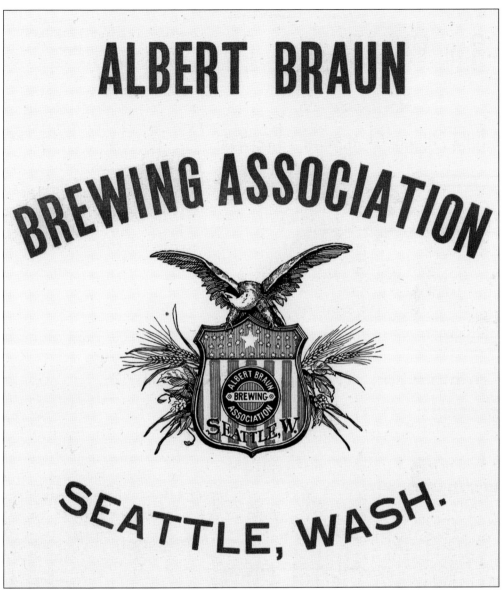

The Albert Braun Brewery Association was created in 1890. During its brief existence, it brewed two primary brands: Standard and Columbia Beer. In 1893, it partnered with the Clausen-Sweeney Brewing Company and the Bay View Brewing Company to form the phenomenally successful Seattle Brewing and Malting Company. Albert Braun died a few years later, and the brewery continued to be used until it was destroyed by fire in 1899. (Charles Finkel.)

Another early beer pioneer was Samuel Simon Loeb, who was born in Ligonier, Indiana, in 1862. The son of a prominent brewer, he moved to Tacoma in 1889 and became president of the Milwaukee Brewing Company of Tacoma. In 1902, having sold his business interests, he moved to Seattle and, alongside his father, led a handful of investors to form the Independent Brewing Company. (Author's collection.)

The Independent Brewing Company operated in Seattle from 1902 to 1915. Its first beer was a Pilsner-style lager, followed by Special Brew and later its popular Old German Lager. By 1909, the brewery employed 40 men and had an annual output of 30,000 barrels. While most of its beer was consumed locally, the brewery exported a sizable amount to Siberia and Alaska. (Charles Finkel.)

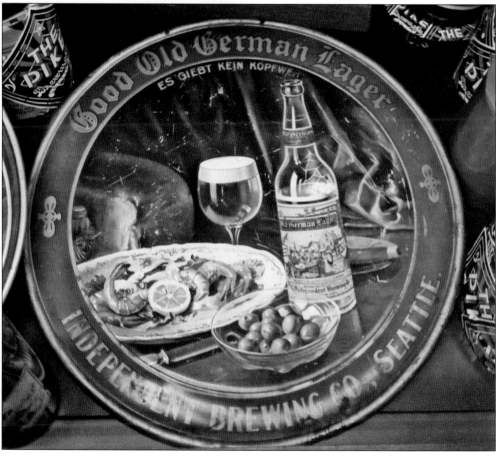

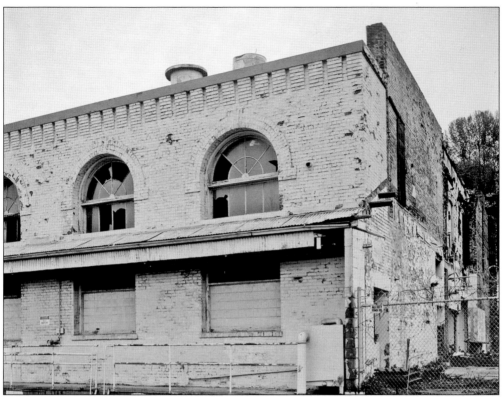

The Independent Brewing Company was located on Airport Road, north of the Bay View (Rainier) Brewery. After Prohibition, it housed a bottling works for a time and was most famously known as the Sunny Jim's peanut butter factory. This photograph was taken shortly before the building was destroyed by fire in 2010. (Gary Pomeroyq.)

Old German Lager

and "Independence Day"

ARE INSEPARABLE COMPANIONS
THEY GO HAND IN HAND

NEXT MONDAY IS

The 4th of July

The Weather Prophet Predicts a Fine Day

Long Natural Storage

the old-fashioned process of aging, produces

Old German Lager

thereby retaining the "Vital Phosphates" of "Malt" and the food elements of "Bohemian Hops." Place your order early. A fact: "Es giebt kein kopfweh."

The Independent Brewing Co.

Phones: Independent 58; Sidney 75

This is a 1910 Independence Day advertisement for the Independent Brewing Company. (Author's collection.)

21

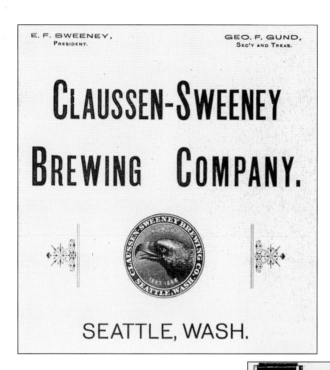

In 1882, Edward F. Sweeney arrived in Seattle from San Francisco and established the Puget Sound Brewery in Georgetown with business partner William J. Rule. Sweeney later bought out Rule's share of the company and added brewmaster Hans J. Claussen as a principal investor. The operation was renamed Claussen-Sweeney Brewing Company. This advertisement appeared in the 1893 Polk, Seattle, directory. (Seattle Public Library.)

In 1891, Claussen sold his interest in the brewery and started the Claussen Brewery Association in the Interbay neighborhood of Seattle. At its peak, the brewery produced more then 25,000 barrels of beer and employed 50 men. Its product was exported as far as Russia, the Philippines, and Alaska. Its flagship beer, Tannhaeuser, had the tagline, "Tannhaeuser Beer Promotes Good Cheer." This advertisement promoted free Tannhaeuser-branded noisemakers for the opening of the 1909 Alaska-Yukon-Pacific Exposition, Seattle's first world's fair. (Author's collection.)

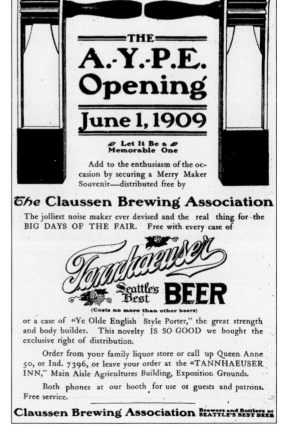

Two

THE RISE OF RAINIER

In 1891, Portland and Seattle Breweries, Ltd., a London investment firm, was created with a capital investment of $370,000 and, within a month, bought controlling interests in the City Brewery of Portland, Seattle's Clausen-Sweeney and Bay View Brewing Company, and Star Brewery of Walla Walla. When the company was forced to dissolve its holding a few years later after an economic depression hit the United States in 1893, Andrew Hemrich saw his opportunity. After regaining control of his Bay View Brewery, he consolidated with the Claussen-Sweeney and Albert Braun Breweries to form the Seattle Brewing and Malting Company. The company's management carried over from its prior firms with Andrew Hemrich as president, Albert Braun as vice president, Edward F. Sweeny as secretary, and Fred Kirschner as treasurer. The brewery's first beer was named Rainier, a tribute to the majestic mountain seen on the brewery's southern horizon. Over the next 20 years, Seattle Brewing and Malting Company achieved phenomenal success. Rainier quickly became the Northwest's most popular beer, and as shipping channels opened, it became one of America's most exported as well. Millions of bottles of Rainier were exported to Canada, the Philippines, and as far as China. By the 1910s, Seattle Brewing and Malting Company was the largest single industrial enterprise in the state of Washington and the sixth largest brewery in the world.

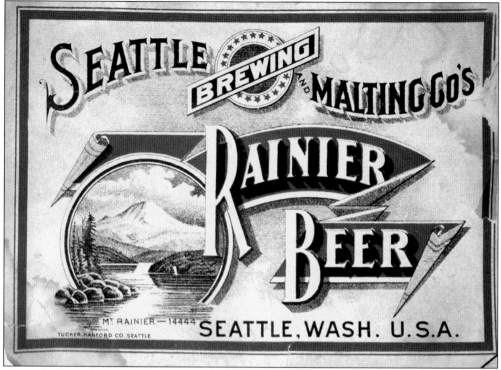

Pictured is an early Rainier bottle label from the Seattle Brewing and Malting Company. Rainier was first introduced in 1893 and was the brewery's first beer (Author's collection.)

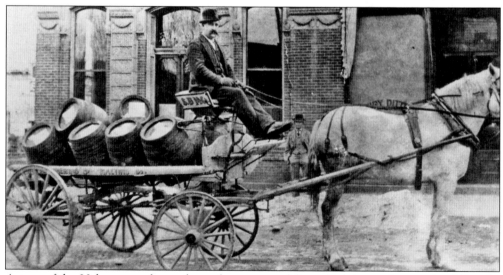

A turn-of-the-20th-century horse-drawn beer wagon delivers Rainier to the people of Seattle. (Author's collection.)

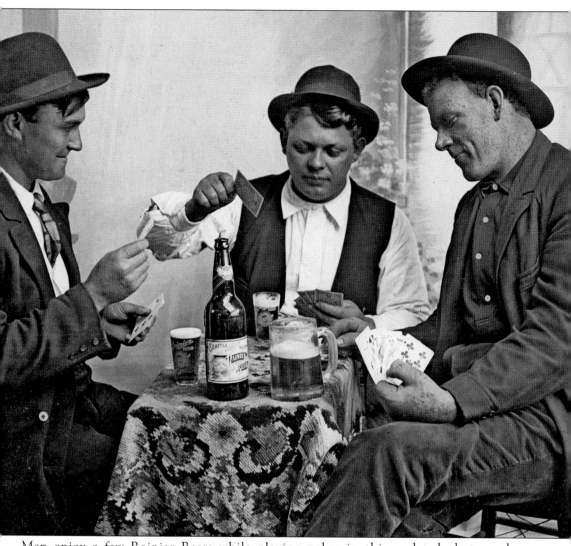

Men enjoy a few Rainier Beers while playing poker in this undated photograph. (Patrick McManus.)

Nothing to see here; just an elegant woman relaxing with a scary-looking bear on this Seattle Brewing and Malting Company serving tray from 1913. (Michael Magnussen.)

Pictured below is a 1909 letter from the Seattle Brewing and Malting Company to the King County auditor. Start-up money was often fronted by breweries to perspective tavern owners prior to Prohibition. The breweries paid everything from the purchase price of the building down to the cost of its liquor license. In return, the tavern owner agreed to only serve the respective brewery's beer. The lack of regulation made these types of deals incredibly flawed, often leaving the tavern owner at the mercy of the brewery. (King County Archives.)

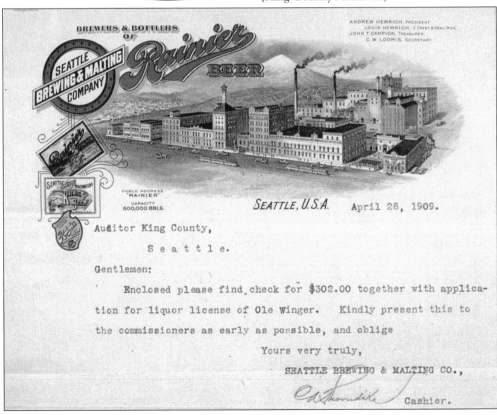

BREWERS & BOTTLERS OF

ANDREW HEMRICH, President
LOUIS HEMRICH, V Pres & Genl Mgr
JOHN T. CAMPION, Treasurer
C. W. LOOMIS, Secretary

SEATTLE BREWING & MALTING COMPANY

Rainier BEER

CABLE ADDRESS "RAINIER"
CAPACITY 600,000 BBLS.

SEATTLE, U.S.A. April 28, 1909.

Auditor King County,

 Seattle.

Gentlemen:

 Enclosed please find check for $302.00 together with application for liquor license of Ole Winger. Kindly present this to the commissioners as early as possible, and oblige

 Yours very truly,

 SEATTLE BREWING & MALTING CO.,

 Cashier.

The cooperage and carpenter shop shown in this 1914 photograph occupied the building formally used as a powerhouse by the Seattle Electric Company. Before the advancement of aluminum barrels in the 1950s, breweries often had large cooperage shops where workers made hundreds of wooden casks every day (UW Special Collections.)

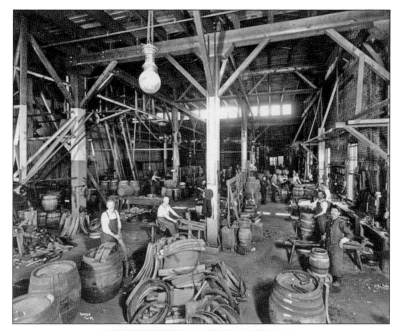

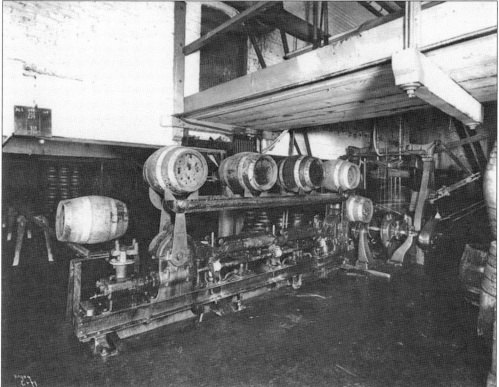

The Seattle Brewing and Malting Company's washhouse adjoined the cooperage and carpenter shop and was 80 feet by 160 feet in size. Previously used beer barrels had to be thoroughly washed, dry steamed, and relined with pitch to prevent contamination when reused. (UW Special Collections.)

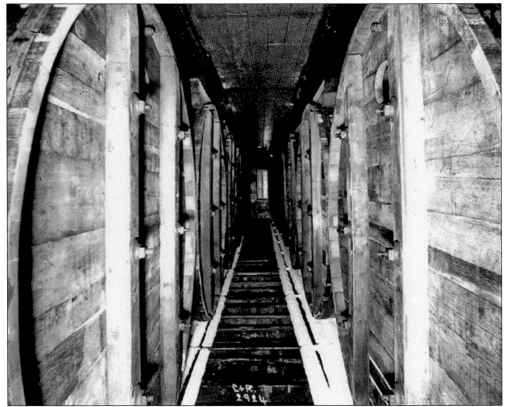

The Seattle Brewing and Malting Company vat room is seen here in 1907. The vat room was an enormous space used to ferment and store beer. The room held 450 of these large wooden vats, and each vat had a capacity of 275 barrels. The room also included 64 glass-enameled tanks and 100 fermenting tanks. (UW Special Collections.)

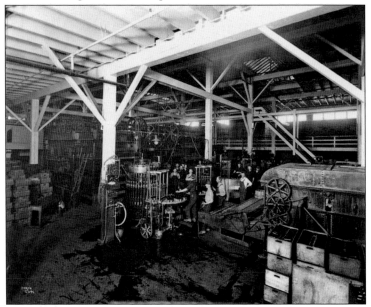

From the vat room, the beer was sent through filtering machines and into the adjoining filling department. At its peak, Seattle Brewing and Malting Company had two shifts of 15 men working 10-hour days and filling up to 60 casks of beer a minute. (UW Special Collections.)

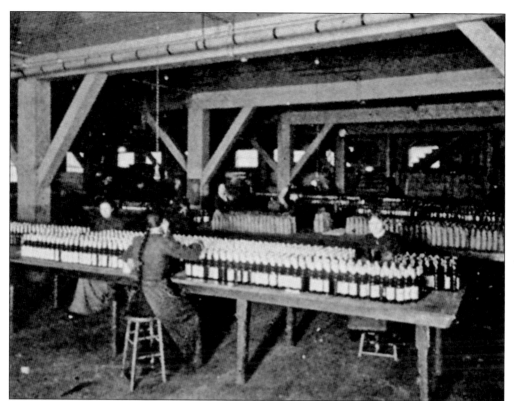

A crew of workers was also responsible for tin foiling each bottle of Rainier Beer, as shown in this 1900 photograph. By 1908, Seattle Brewing and Malting Company were producing three different beers: Bohemian, Pale, and its flagship, Rainier Beer. They also produced a self-proclaimed medical tonic named Malt Rainier. (Author's collection.)

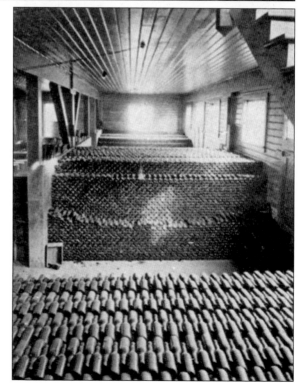

This 1900 photograph shows the many thousands of empty bottles being stored by Seattle Brewing and Malting Company. While the brewery owned its own glassworks company, enormous demand for Rainier Beer called for additional bottles. In 1905, the Star Glassworks Company, located in Renton, was supplying the brewery with up to 12,000 glass bottles a day. (Author's collection.)

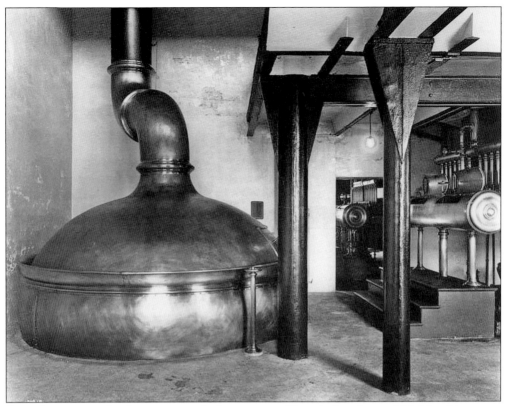

One of two copper kettles is seen in the brew room of Seattle Brewing and Malting Company. The kettles were 16 feet in diameter with a combined capacity of 750 barrels. Each kettle could accommodate up to three brewing sessions a day for daily a total of 2,250 barrels worth of beer. (UW Special Collections.)

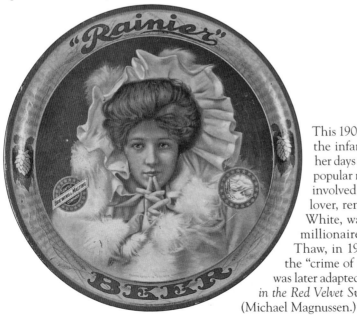

This 1903 Rainier Beer tray featured the infamous Evelyn Nesbit during her days as one of the country's most popular models. Nesbit later became involved in scandal when her former lover, renowned architect Stanford White, was murdered by her jealous millionaire husband, Harry Kendall Thaw, in 1906. Newspapers labeled it the "crime of the century," and the story was later adapted in the 1955 movie *The Girl in the Red Velvet Swing*, starring Joan Collins. (Michael Magnussen.)

In 1905, the Seattle Brewing and Malting Company held a photography contest to find the "prettiest damsel on the coast." Fifteen-year-old Seattle resident Hazel McKinnon was chosen as the winner and received a $100 prize. Her likeness was used in the company's 1906 promotional art calendar and appeared on this serving tray produced by the brewery. (Michael Magnussen.)

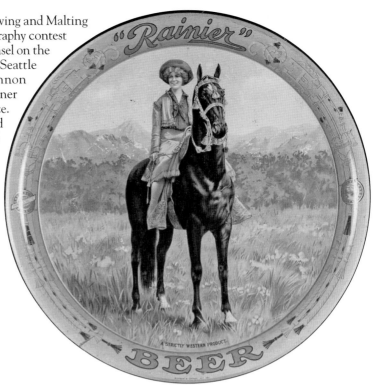

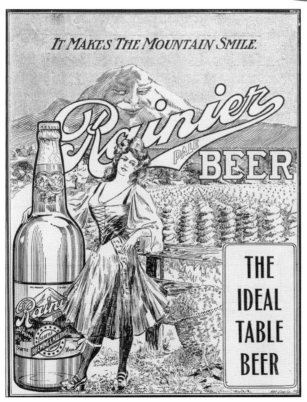

"It makes the mountain smile." This advertisement for Rainier Beer appeared in the *Pacific Monthly* magazine in 1907. (Seattle Public Library.)

Announcement

It is the pleasure of the Seattle Brewing and Malting Company to inform its friends and patrons that we are prepared to fill all orders for our new *Rainier Pale* brand of beer, which has met an exacting demand in the City of Seattle. Discriminating drinkers pronounce it the equal, if not the superior, of any Eastern or Western bottled beer. This is a specially brewed beer for bottling only. It will be sold in light bottles exclusively, and bottled only at our plant. The choicest Barley, East India Rice and Select Bohemian Hops will be used in its production. It will be found thoroughly ripe and mellow, and with an exquisite after-taste, which is the proof of a strictly high-grade bottled beer. It will please you. Order from the

Seattle Brewing and Malting Company

Sunset Phone Exchange 27. Independent 27.

In 1906, Seattle Brewing and Malting Company introduced Rainier Pale, a variation of Rainier Beer that was brewed specifically for bottling. (Author's collection.)

Seattle Brewing and Malting Company hired Spokane-based musician and composer J. Louis MacEvoy to create a song involving Rainier Beer. "There's Something Else Goes With It!" was published in sheet music form by the brewery in 1907 and given away as a promotional item. Parts of its chorus were "Yes, something else goes with it, and to you its very clear, there's something else goes with it, What? Rainier, Rainier, Rainier." Released in a time before the radio jingle, this very well could have been the first advertising song in Seattle's history. (Charles Finkel.)

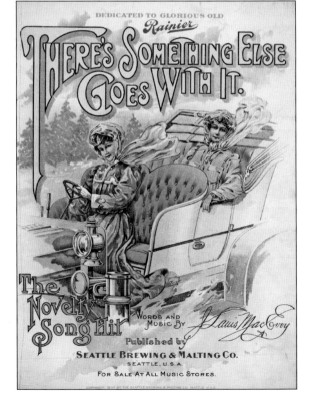

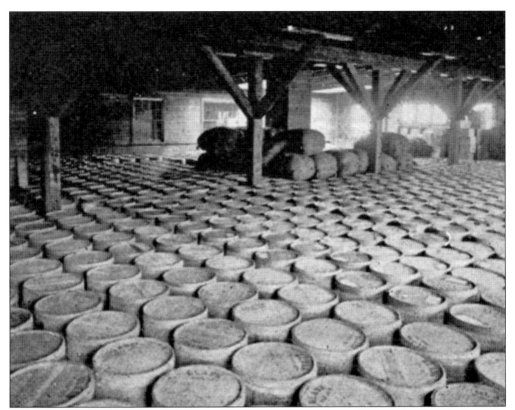

Hundreds of wooden casks of Rainier Beer await shipment in 1900 at the Seattle Brewing and Malting Company. By 1911, the brewery was selling over 800,000 of these casks a year. (Author's collection.)

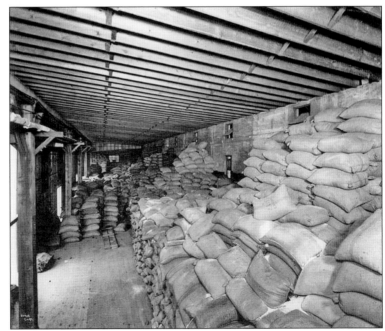

Large quantities of malt were stored in the Seattle Brewing and Malting Company's malt room. The room was specifically designed for its storage. (UW Special Collections.)

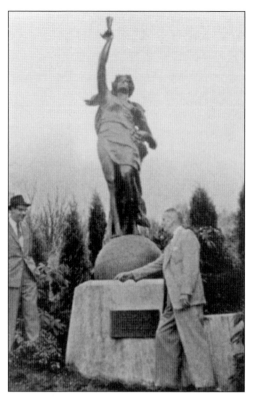

Emil Sick (right) stands before the *Lady Rainier* in this photograph from the late 1940s. The statue was imported from Germany by the Seattle Brewing and Malting Company in 1903. Originally, it was part of a large fountain that, for many years, stood on the roof of the brewery. In 1954, Emil Sick moved the statue to his Rainier Brewery, located two miles north. The statue still stands today at the former Rainier Brewery, now Tully's Coffee's headquarters. (Author's collection.)

Seattle Brewing and Malting Company commissioned Binner Engraving Company for a series of advertisements around the turn of the 20th century. The Chicago-based company, established by Oscar Binner, was regarded as one of the country's top art agencies for many years. (Seattle Public Library.)

THE BREW OF ALL BREWS
RAINIER BEER

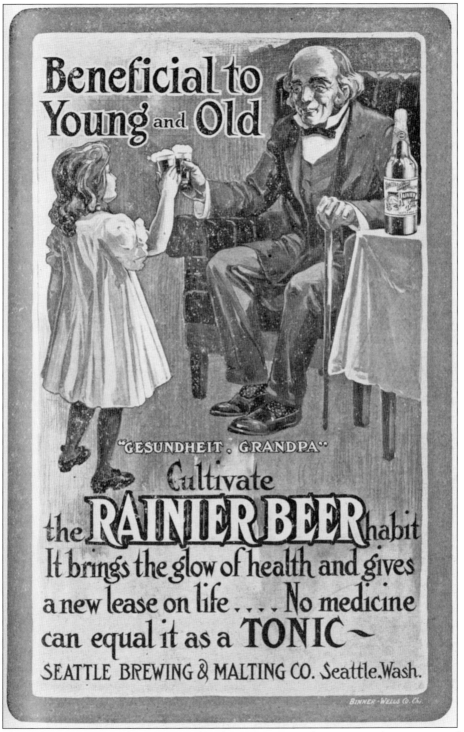

This bewildering 1906 Seattle Brewing and Malting Company advertisement shows a young child enjoying a full glass of Rainier Beer with her grandfather. This was likely the last time he was allowed to babysit the child. (Seattle Public Library.)

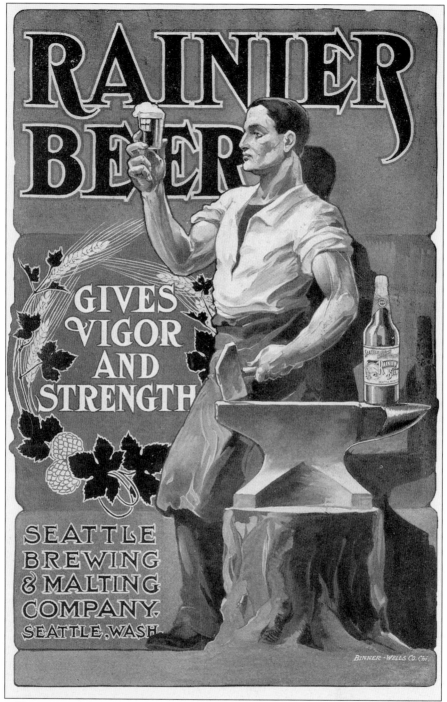

Pictured here is another advertisement for Rainier Beer, created by Binner Engraving Company. In 1904, the temperance movement in Washington started to gain serious momentum. Georgetown was an unincorporated town, which left the brewery vulnerable to many of the new state Prohibition laws that were starting to take shape. To protect its interest in the brewery, the 2,500 residents voted in January of that year to become an incorporated city. (Seattle Public Library.)

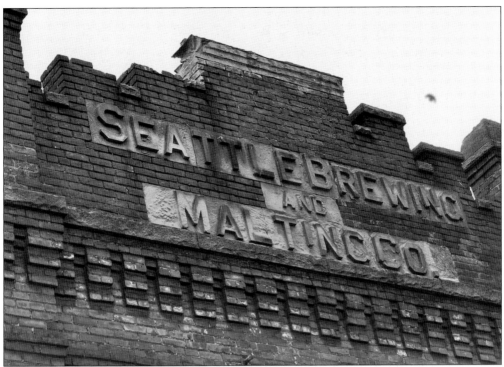

After incorporating in 1904, Georgetown became a true company town and made no attempts to disguise it, even having the brewery's superintendent, John Mueller, elected as its first mayor. The Seattle Brewery and Malting Company, now free of many restrictions, aggressively started to expand its operations. Over the next few years, it spent today's equivalent of about $100 million on brewery additions and equipment. These photographs of the brewery show the company's nameplate as it still looks today. (Both, author's collection.)

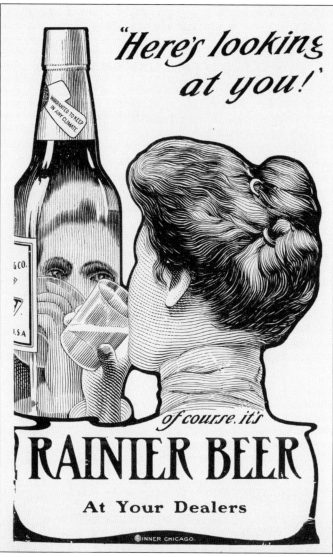

Long before it was associated with Humphrey Bogart, "Here's looking at you" was a popular phrase used for toasts at dinner parties and celebrations. This strange 1903 advertisement for Rainier Beer uses the phrase while showing a sad-eyed woman drinking alone as she stares at her own reflection in a giant bottle of Rainier. (Seattle Public Library.)

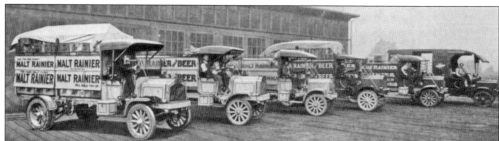

Starting in 1911, the brewery invested $150,000 in motor equipment from the Packard Motor Company. Twenty-six motor carriages and 24 trucks were purchased. Each carried 60 cases of beer inside and had room for 40 empty cases on top. The efficiency and power of each truck was able to replace three horse-and-buggy delivery teams. This photograph of the brewery's Packard line up was taken in 1913. (Author's collection.)

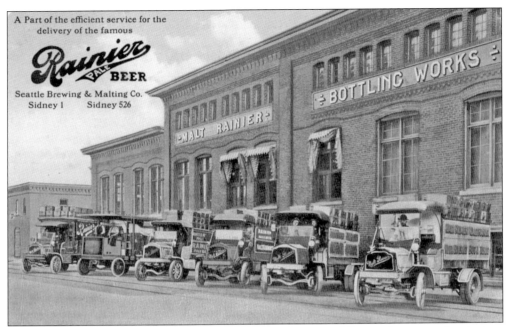

A Part of the efficient service for the
delivery of the famous

Rainier PALE BEER

Seattle Brewing & Malting Co.
Sidney 1 Sidney 526

Tired of Georgetown's lawlessness and corruption, Seattle successfully voted to annex the city into its own jurisdiction in 1910. That same year, women (whom the vast majority of were supportive of the temperance movement), were allowed to vote, making the possibility of statewide Prohibition a greater threat. This 1912 postcard shows a line up of Rainier delivery trucks in front of the 1906 Seattle Brewing and Malting Company. The photograph below shows what the same section of the brewing company looks like today, 100 years later. (Both, author's collection.)

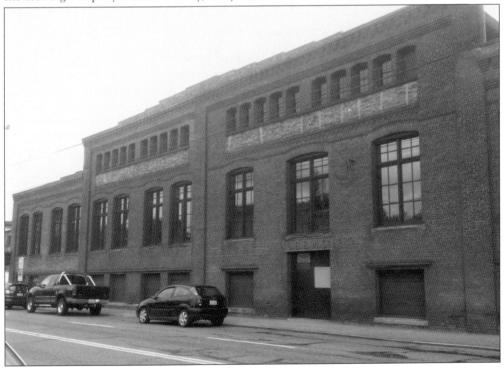

39

Malt extracts and tonics became a popular product of breweries starting in the decade proceeding statewide Prohibition. Even though most of them were likely nothing more than slightly modified alcoholic beer, breweries marketed them as health-promoting tonics that were ideal for invalids, insomniacs, nursing mothers, and even children. As the temperance movement intensified, Seattle Brewing and Malting Company continued to heavily advertise its Malt Rainier in an attempt to highlight the company's redeeming qualities. (Seattle Public Library.)

When Initiative Measure No. 3 (prohibiting the manufacture and sale of liquor statewide) made the ballot in 1914, the Seattle Brewing and Malting Company began to campaign against the initiative in a series of direct pleas to voters, such as this one from March 1914. On November 3, 1914, voters approved the measure by a slim margin. Seattle citizens and other metropolitan areas of the state overwhelmingly voted against the initiative, but strong support from small town and rural areas proved enough for the measure to pass. Breweries were given a little over a year to liquidate their supply of alcoholic beers and immediately started laying off the workforce. It was 17 years until alcohol was legal again. (Seattle Public Library.)

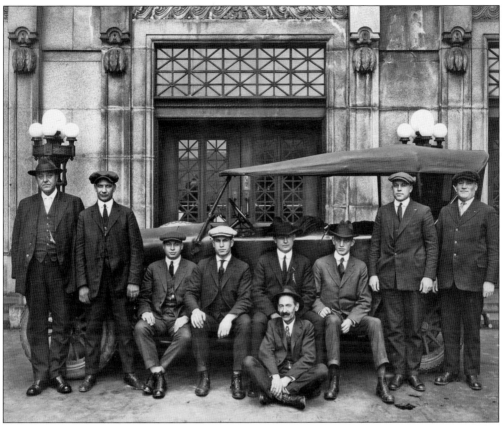

This 1921 photograph shows the Seattle Police Department Dry Squad, a special force assembled to raid homes and businesses suspected of violating the alcohol ban during Prohibition. (Seattle Municipal Archives.)

Within two months of the law's passing, Louis Hemrich, then president of the Seattle Brewing and Malting Company, secured plans to move his company to San Francisco, California, confident that national Prohibition would never come to fruition. The sixth largest brewery in the world was leaving Seattle and running liquidation advertisements like the one seen here. (Author's collection.)

FOR SALE
HEAVY TRUCKS AND ROLL WAGONS

In our way; must be disposed of quickly. Come out and make us an offer.

Seattle Brewing and Malting Co.

PHONE SIDNEY 1

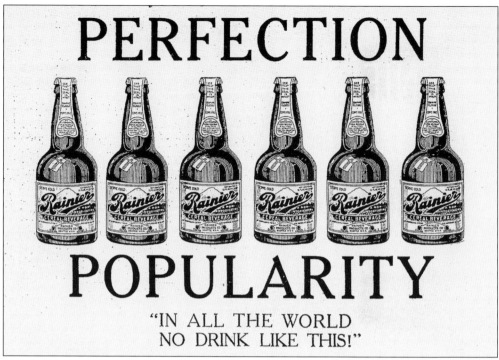

PERFECTION

POPULARITY

"IN ALL THE WORLD
NO DRINK LIKE THIS!"

The Seattle Brewing and Malting Company formed a separate company and continued to run a vastly downsized version of its Georgetown brewery. Rainier Products manufactured a number of non-alcoholic beverages, including Rainier Special, Rainier Bock, a table syrup christened Syro, and Rainier Cereal Beverage, seen in this 1917 advertisement. (Seattle Public Library.)

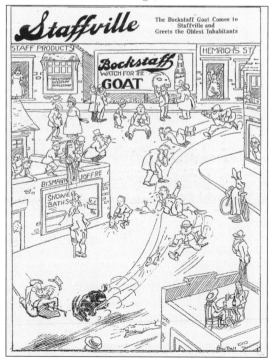

Hemrich Bros. Brewing Co. quickly converted into a near beer plant as well. The company changed its name to Hemrich's Staff Products Company and released a number of products, including Lifestaff, Bockstaff, and Applestaff (a sparkling apple juice). Near beer (also known as cereal beverage) tasted somewhat like beer but with little or no alcohol. Many breweries survived selling near beer but few, if any, considered sales of the beverages a success. This 1917 cartoon shows just how truly frustrating and sad the world of "Staffville" was without real beer. (Author's collection.)

After brewing operations were completely shut down in the Georgetown brewery, Rainier Ice, a company that manufactured ice for residential and commercial uses, occupied the cold storage area of the building for a number of years. (Author's collection.)

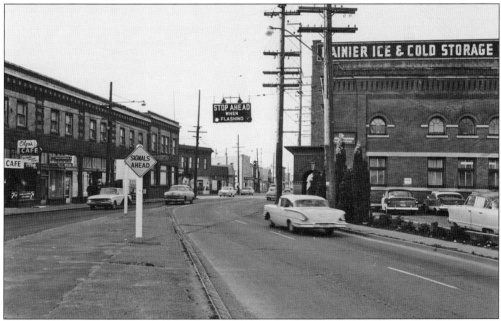

Rainier Ice, seen at right in this 1960 photograph, later added cold storage to its list of services and continued to operate in the former brewery until 2001. (Seattle Municipal Archives.)

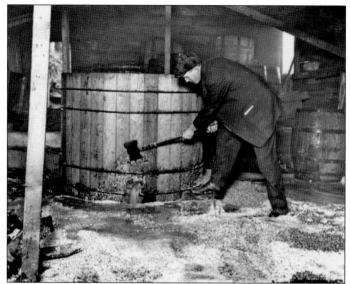

Enforcing Prohibition proved draining on the resources of both federal and local authorities. This photograph from 1925 shows a member of the Seattle Dry Squad using an axe to destroy a confiscated vat of alcohol. (UW Special Collections.)

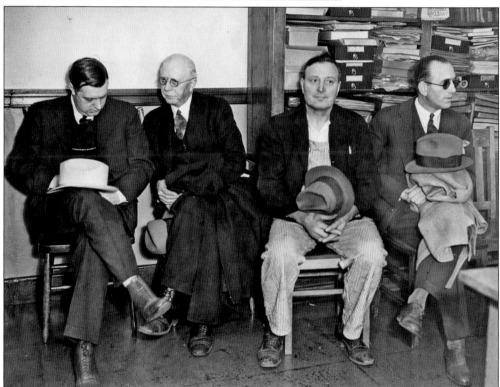

On June 8, 1932, Alvin Hemrich (second from left), along with his son Elmer and six associates, were arrested by federal Prohibition agents after an undercover investigation revealed that Hemrich was selling materials for the home manufacturing of alcoholic beer, a clear violation of the Prohibition law. The story made front-page news, as Alvin Hemrich was still a well-known Seattle businessman from his days at the Hemrich Bros. Brewing Co. Alvin's trial was postponed, and the case was later dropped after the repeal of Prohibition. This 1932 photograph was taken shortly after their arrest. (Author's collection.)

Three

HAPPY DAYS
ARE HERE AGAIN!

On November 8, 1932, voters passed Initiative No. 61 (the repeal of all Washington's liquor laws), clearing the way to end Prohibition in the state of Washington. The sale of beer up to 3.2 percent alcohol was once again legal in Washington State. Familiar names from Seattle's past quickly made plans to reenter the market. On April 7, 1933, at the stroke of midnight, Hemrich Bros. Brewing Co. and Rainier Brewing Company of San Francisco were prepared to reenter the Seattle market, using part of the old Georgetown brewery as a distribution center. Later that same year, George Horluck, owner of a popular chain of ice cream parlors, built a brewery at the corner of Westlake Avenue and Mercer Street, and by June of that year, the Horluck Brewing Company was selling its Danish-style draught beer. After a long 17 years, Seattle was once again brewing beers and ready to be put back on the map.

TONIGHT AT MIDNIGHT— HISTORY REPEATS ITSELF

Rainier BEER

RETURNS TO LEADERSHIP!

IT'S HERE AGAIN to cheer again! Famous Rainier Beer! Supreme among beverages of the West, it has a zest and a sparkle you'll never forget and a tang that leaves you refreshed.

Properly aged, Rainier has a rare, old mellow flavor. Into this highest quality beer go the finest ingredients that money can buy—selected barley malt, hops and yeast.

Then is added the most precious ingredient of all: 54 years of Rainier experience that blends these into a beverage that's superfine—that's healthful—and that possesses a flavor so distinctive you'll judge all other beers by this kind.

Order Rainier today. — — — — — Look for that famous label of yesterday that marks the finest beer of today! Insist on Rainier, too, when you are dining out. Served in all leading hotels, clubs and restaurants.

RAINIER BREWING CO.
Largest brewery west of St. Louis

Since 1879

The Rainier Brewing Company of San Francisco once again supplied Seattle with Rainier Beer. Although the city's favorite beer was no longer brewed locally, Seattleites loyalty for Rainier remained strong and the beer once again became the city's top-selling beer. (Author's collection.)

This 1937 photograph shows Horluck Brewing Company owner George Horluck (center) with the company's sales managers and executives. Horluck's brewery was located at 606 Westlake Street North. (Stan Sherstobitoff.)

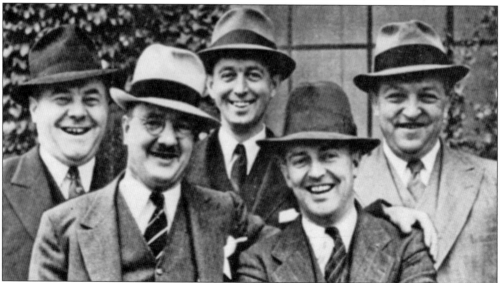

Horluck's Vienna-style beer was a lager beer developed for the Horluck Brewing Company by brewmaster Adolph Verhill. Vienna is a lighter-body style of lager that generally appears copper-colored and has a sweetness similar to an amber-style of beer. (Stan Sherstobitoff.)

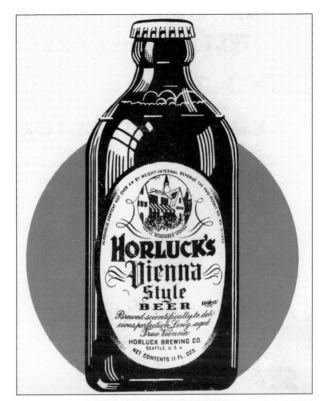

In this late-1930s photograph, a Horluck delivery truck is being loaded with barrels of Horluck's fire-brewed Vienna Beer. (Stan Sherstobitoff.)

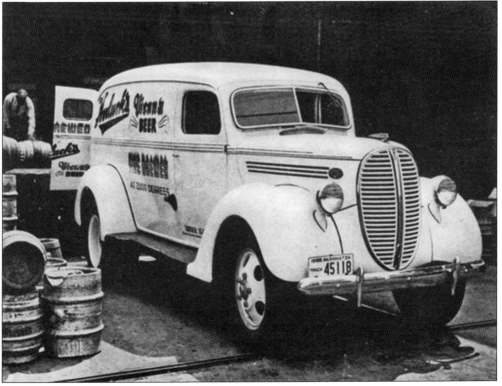

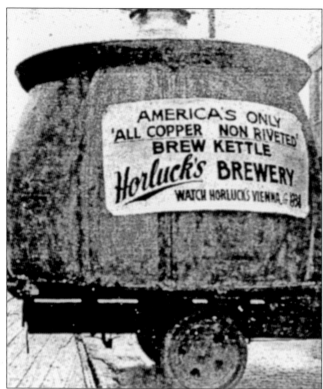

In 1938, Horluck Brewing Company introduced its new fire-brewed Vienna Beer. "Fire-brewed" referred to the type of heat source used on the brew kettle to boil the unfermented beer. Fire brewing was a popular method in Europe before steam heating became more practical. This 1938 photograph shows the giant copper brew kettle Horluck used for the brewing of the beer as it was paraded across the streets of Seattle. The kettle could hold 212 barrels of beer per batch and was made locally by the Alaskan Copper Works Company. (Stan Sherstobitoff.)

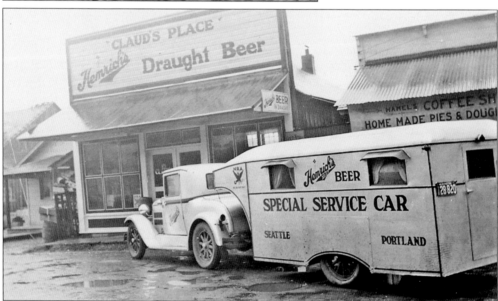

Alvin Hemrich continued his family's Seattle brewing tradition when he opened the Hemrich Brewing Company in April 1933. Alvin previously served as the initial investor and president of the Hemrich Bros. Brewing Co. and spent much of Prohibition running canneries before reentering the Seattle beer industry. This image, captured around 1935, shows Hemrich Bros. Brewing Co.'s special service car visiting Claud's Place, a heavily Hemrich-sponsored tavern located in Portland, Oregon. (Travis Sterne.)

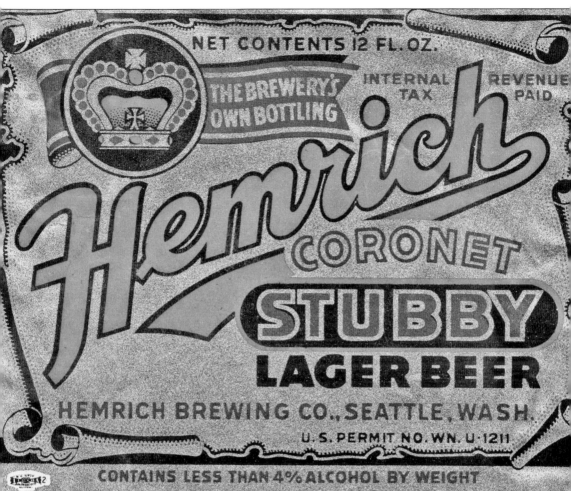

This beer label was used for Hemrich Cornet Lager Beer. The Hemrich Bros. Brewing Co. operated two breweries after Prohibition, both located on opposite ends of the SoDo area of Seattle. His first brewery was located next to the old Bay View Brewery at 2918 Airport Way, while the other was converted from a bar soap factory located at 5225 East Marginal Way. (Author's collection.)

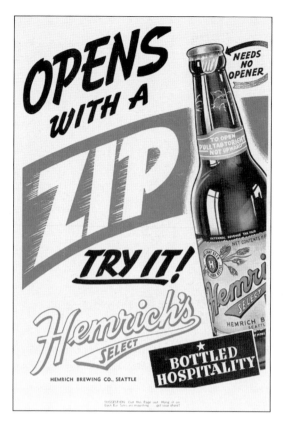

Hemrich Select, as shown in this 1939 advertisement, was a popular Seattle beer prior to Prohibition and was reintroduced in 1933. In 1934, Alvin Hemrich sold his interests in one of his two Seattle breweries, along with the rights to the Hemrich brands, to Rudy Samet. Hemrich then upgraded his brewery located next to Emil Sick's on Airport Way, reopening under the name Apex Brewing Company. (Stan Sherstobitoff.)

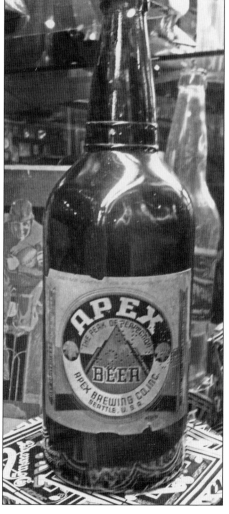

Alvin Hemrich's new brewery, Apex Brewing Company, had the tagline, "The Peak of Perfection." Apex sales never neared that of its competitors, and after Hemrich died in 1935, the brewery was sold to Emil Sick a few years later. Sick continued to use the building to brew his Rheinlander Beer for another year before converting it into a central quality-control laboratory for all of the breweries in his organization. The structure was razed in 1965 due to damages the building sustained in an earthquake. (Charles Finkel.)

Rudy Samet, now president of the Hemrich Bros. Brewing Co., added Happy-Peppy Beer to the line up in 1934. This promotional wooden advertising sign was manufactured shortly after its release. The oddly named beer never was a big seller and was discontinued three years later. (Michael Magnussen.)

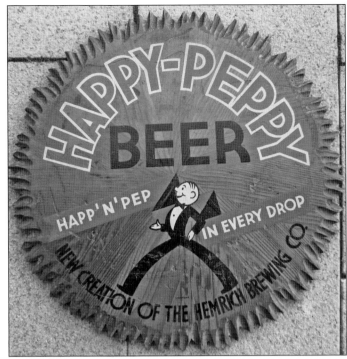

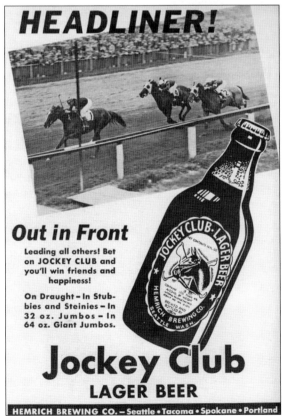

After Happy-Peppy Beer's sad demise, the company found itself in financial trouble. Jockey Club Lager was introduced in 1937 to some success, but sales were not nearly enough to continue operating the company. The brewery and assets were soon sold to Emil Sick for $30,000. This marked the end of the "House of Hemrich" Seattle-brewing empire. (Author's collection.)

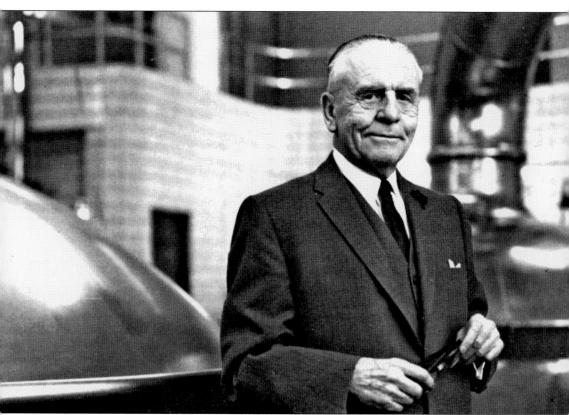

Emil Sick entered the Seattle beer market by renting the old Bay View Brewery at a rate of $250 a month. Beer had not been brewed there in over 20 years, and the building had spent the last 14 years as a flour mill. Sick invested $75,000 in the complete remodeling and modernization of the building, leaving only the brewery's original walls in place. Within months, Century Brewing was operating. This mid-1950s photograph shows Sick in his Rainier Brewery. (Author's collection.)

Four

EMIL SICK'S EMPIRE

As an industrialist, the successful brewer is not a small figure in the community. His industrial prominence brings him to the forefront and imposes upon him the obligation to take a keen and helpful interest in civic and national affairs. In the best sense of the word, he should be both business man and civic leader. Business man in that he conducts his business soundly, and a leader in serving his community and nation with broad unselfishness.

—Emil Sick
Rainier Brewing Company president, 1942

The story of Emil Sick's life begins with his father. Fritz Sick was born in Bavaria, Germany, in 1859. He arrived in the United States in 1883 with $5 in his pocket and a ticket to Cincinnati, which was then a major brewing center. Fritz was an experienced cooper in his native land and easily found work in the area breweries building wooden beer casks. He eventually moved to Tacoma to work at the Hulth Brewery in 1899 and later married Louise Frank. It was there that Emil Sick was born in 1893. Fritz then set his sights on Canada, founding his first brewery in Lethbridge in 1901. The brewery flourished, and soon the Lethbridge Brewing and Malting Co. was producing over 40,000 barrels a year.

After two years at Stanford University, Emil, despite his father's objections, left the university and joined his father at the brewery. From there, they created a Canadian brewery empire, buying breweries in Prince Albert, Edmonton, and later Vancouver just as Prohibition in Canada was lifted.

By 1933, Prohibition had also ended in the United States, and Emil and his father saw opportunity. After buying breweries in Montana and Spokane, Washington, Emil looked to Seattle for the company's next expansion. Recognizing the great history and sales potential of Rainier Beer in the Northwest, Emil first approached the Rainier Brewing Company of San Francisco about the possibility of leasing the name *Rainier* for his first Seattle beer. When Rainier rejected the proposal, Emil continued his Seattle expansion plans with an entirely new beer and leased the old Bay View brewing plant. With capital totaling $746,000, the Century Brewing Association was incorporated in June 1933, and on Friday, June 13, 1934, Sick's first beer, Rheinlander, entered the Seattle market. By the end of the decade, Emil Sick was a household name in Seattle and one of its most beloved citizens.

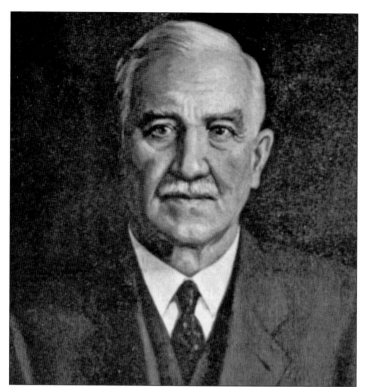

Emil's father, Fritz Sick, headed Sick's brewery enterprises for a number of years and oversaw much of the company's expansion into the Northwest. (Seattle Public Library.)

The shell of the old Bay View Brewery can be seen in this 1938 photograph of Emil Sick's new brewery. Additions to the brewery would continue for the next 60 years. (Washington State Archives.)

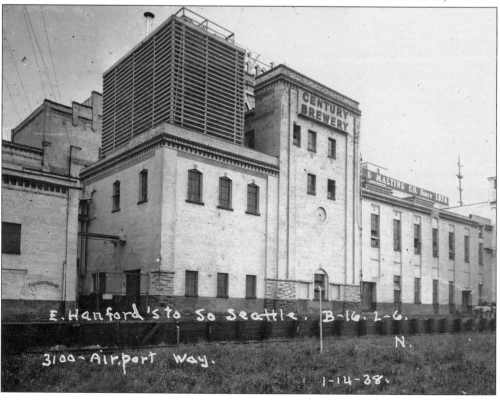

Rheinlander Beer, dubbed "Beer of the Century," was Emil Sick's entry into the Seattle market and was promoted heavily in print and on radio. This image shows the front and back of a Rheinlander advertising coaster from 1934. (Author's collection.)

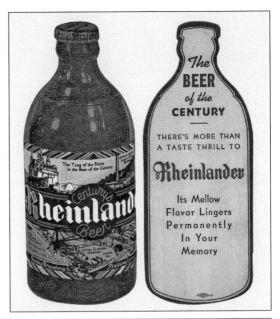

Rheinlander beer was brewed under the supervision of Munich, Germany, native Herr Karl Heigenmooser. So happy with his achievement of Rheinlander, Heigenmooser once boasted to a *Seattle Times* journalist that he often drank seven bottles of Rheinlander while reading the evening paper and again while eating breakfast. This 1938 photograph looks across the front of the brewery from the north end. (Washington State Archives.)

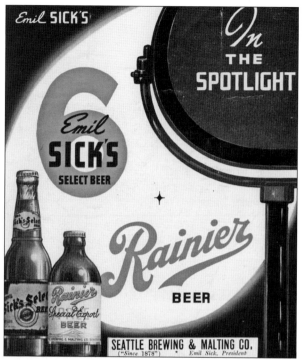

Emil Sick made several trips to San Francisco between 1934 and 1935 in a continued attempt to negotiate the regional rights of Rainier Beer. Although Rainier had been brewed in California since Prohibition, it still had a sizeable sales reach in Seattle and was Sick's main competitor in the Seattle market. Finally, in April 1935, a deal was reached. In exchange for leasing the *Rainier* name, Sick agreed to pay Rainier Brewing Company of San Francisco a royalty of between 75¢ to 80¢ for each barrel of Seattle-brewed Rainier sold. (Stan Sherstobitoff.)

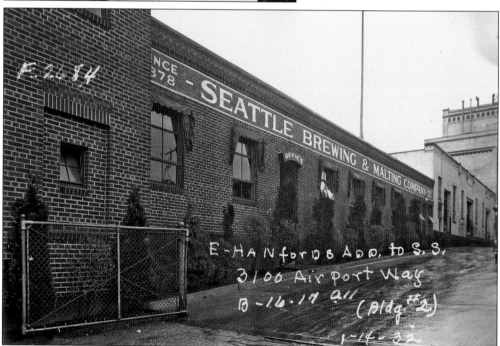

On July 8, 1935, Rainier was brewed in Seattle for the first time in nearly 20 years. To mark the event (and to further confuse Seattle residents of present and future), Emil Sick changed his brewery's name from Century Brewing to Seattle Brewing & Malting Co., the same name of the brewery located two miles south in Georgetown that brewed Rainier Beer prior to Prohibition. This 1937 image shows the office area of the Rainier Brewery. (Washington State Archives.)

The now Seattle-brewed Rainier Beer was an instant success for Emil Sick. In its first year, $2 million worth of Rainier was sold in Washington and Oregon. By 1950, sales grew to nearly $16 million. From 1935 through 1953, he paid close to $2 million in royalties and acquisition costs to Rainier Brewing Company of San Francisco for use of the *Rainier* name. This 1937 photograph shows the addition of Rainier to the brewery's facade. (Washington State Archives.)

In 1938, Rainier Brewing Company became the first Washington brewery to introduce canned beer. The modern beer can, invented only a couple years prior, was still somewhat of a novelty when Seattle residents first saw it. (Stan Sherstobitoff.)

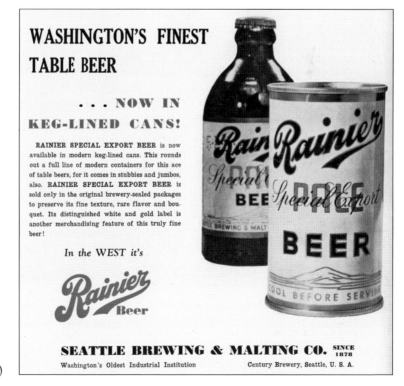

Emil Sick was now one of Seattle's wealthiest citizens and about to also become its most celebrated. In 1937, he purchased the bankrupted Seattle Indians baseball franchise of the Pacific Coast League. Sick renamed the team the Seattle Rainiers and built a new stadium at Rainier Avenue and McClellan Street. Sick's Stadium was constructed at an estimated cost of $250,000 and could seat 14,000 people. (Seattle Municipal Archives.)

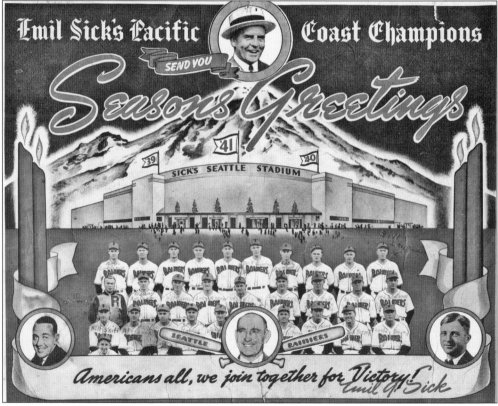

The Rainiers shattered minor-league attendance records year after year and won five PCL pennants in their 27-year existence. This Christmas card was sent out following the 1941 season after winning their third consecutive league championship. (Leon Luckey.)

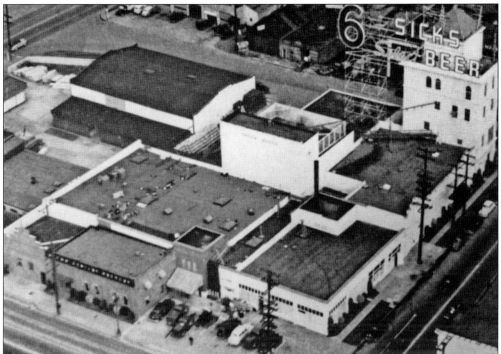

In May 1939, Emil Sick purchased the struggling Horluck Brewing Co. He remodeled and expanded the Westlake-area brewery and reopened it under Sick's Century Brewing, home to Rheinlander Beer. The brewery later committed its resources to brewing Sick's Select Beer. The brewery would be demolished in 1965 and replaced by a gas station. (Author's collection.)

Rainer Old Stock Ale was more robust then regular Rainier and had higher alcohol content. It was originally a product of the Rainier Brewing Company of San Francisco and was first brewed in Seattle in 1937. The first week's sales far outpaced even the brewery's lofty expectations and was sold out within days. The brewery had to run advertisements apologizing for the shortage and promising more Old Stock Ale as soon as possible. (Stan Sherstobitoff.)

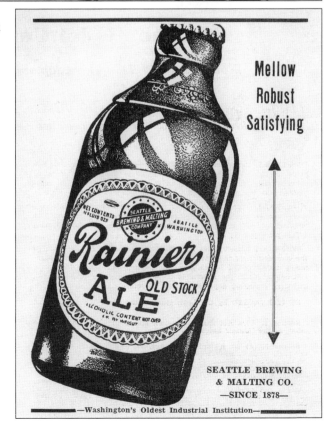

Mellow
Robust
Satisfying

SEATTLE BREWING
& MALTING CO.
—SINCE 1878—

—Washington's Oldest Industrial Institution—

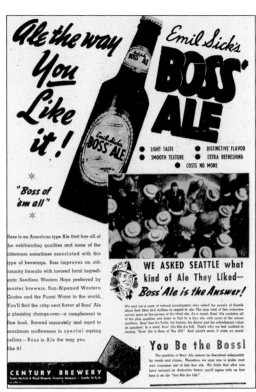

Emil Sick's Boss' Ale was released in 1940 and brewed in Sick's Century Brewery on Westlake Avenue. It is one of the few early beers brewed by Rainier Brewing Company that never achieved much sales success and was quietly discontinued the following year. (Author's collection.)

Among Emil Sick's many civic accomplishments in Seattle was his effort to build King County's first blood bank. Sick led a founder's member committee that raised close to $250,000 in the construction and sustaining fund of the King County Blood Bank. The bank, located at the corner of Terry Avenue and Madison Street, is seen here shortly after its 1944 opening. (Puget Sound Blood Center.)

Pictured here is the Rainier Brewing Company in 1937. Following World War II, the Rainier Brewing Company of San Francisco suffered a sharp sales decline due to increased competition and noticeable spotty product quality. In 1953, Sick's successes allowed him to purchase the entire company. Having wanted only the Rainier trademark, Sick quickly sold the brewery to the Theo Hamm Brewing Company for a handsome profit. After close to 20 years paying royalties for the right to use the name, Rainier Beer was now completely his. (Washington State Archives.)

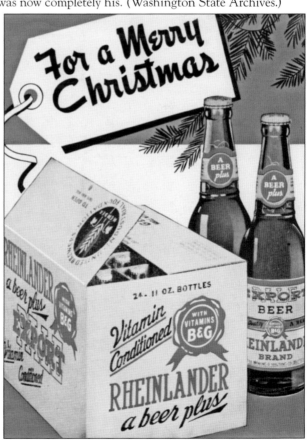

This 1939 Christmas advertisement promotes Rainier Brewing Company's (Century Brewery) Rheinlander Beer. (Stan Sherstobitoff.)

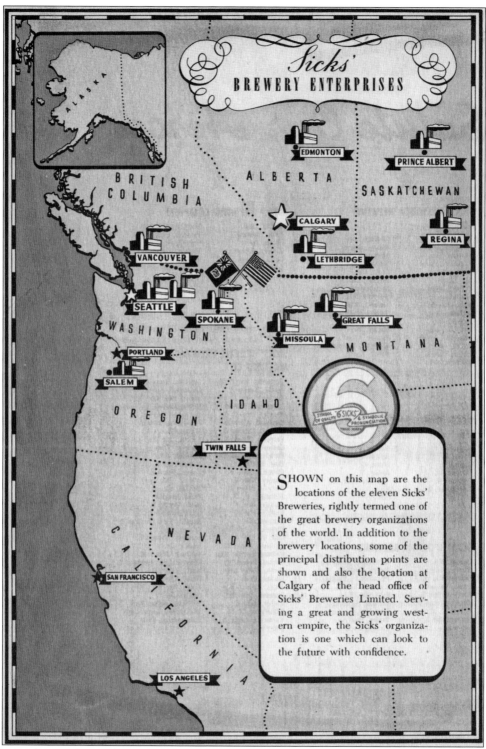

A 1945 map shows the locations of all 11 breweries in mighty Sick's brewery empire. (Author's collection.)

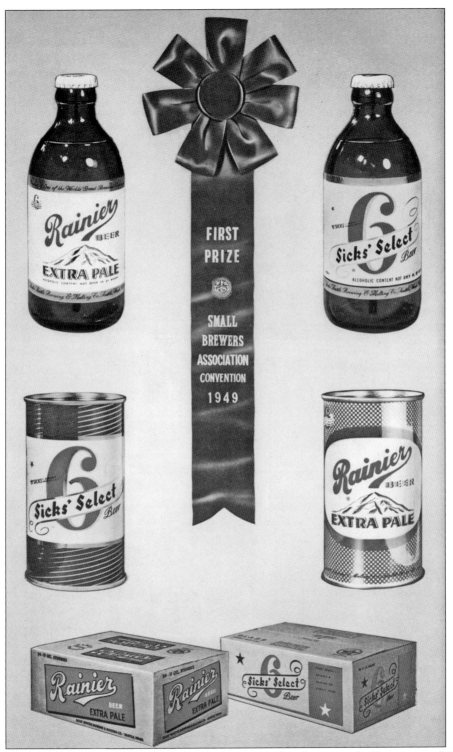

This advertisement shows the Rainer Brewery's complete line up of offerings as of 1949. (Author's collection.)

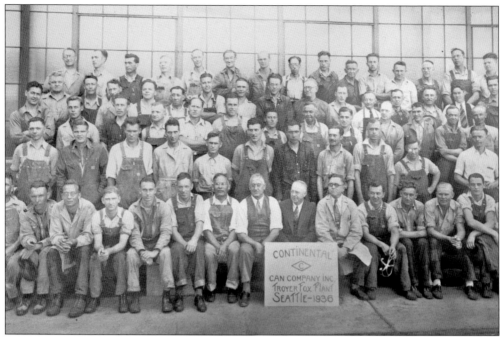

Workers for the Seattle Continental Can Company pose for a company photograph in 1936. The Seattle Continental Can Company produced cans for many of Emil Sick's Seattle breweries and was once the world's largest packaging firm. The company was founded in 1904 and quickly expanded throughout the United States. Its Seattle branch opened in 1927, and by 1934, the company was operating 38 plants. (Author's collection.)

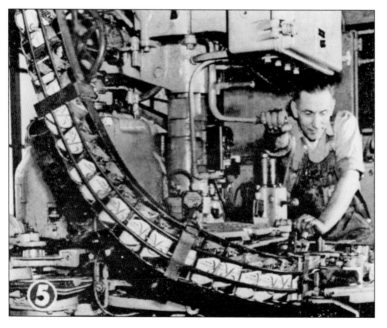

A worker for the Seattle Continental Can Company branch in Seattle makes Rainier cans in this 1954 photograph. In 1934, it was estimated that Continental was making close to two-thirds of the then 10 million cans produced annually in the United States. (Author's collection.)

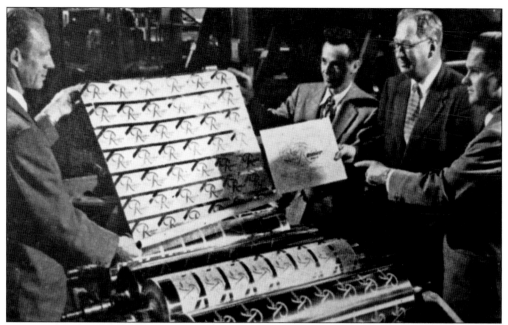

This 1950s image shows Rainier bottle labels being checked for quality as they come off the press at the Pacific Coast Foil Company in San Francisco. (Author's collection.)

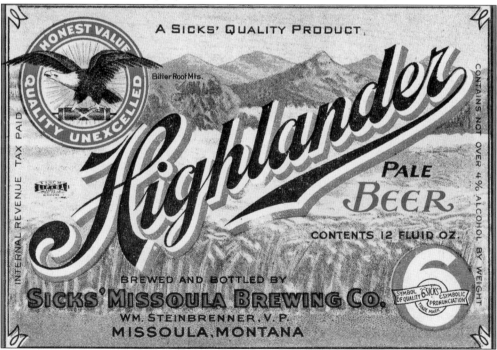

Rainier Brewing Company originally bought the rights to its popular Highlander label for $50,000, and after brewing the product in Montana for a number of years, production switched to Seattle under the company's separate Rheinlander Brewing Company division. Rainier continued to brew Highlander until the early 1980s. Highlander was reintroduced, if only by name, in 2008 by the new Missoula Brewing Company. (Author's collection.)

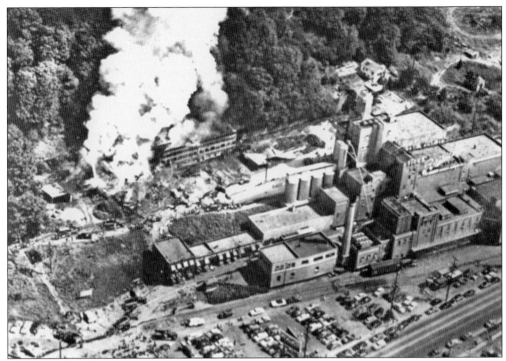

On August 13, 1951, a Boeing B-50 Superfortress bomber experienced engine problems two minutes after takeoff from Boeing Field. The plane grazed Rainier's brewery and crashed into the Lester apartment building directly behind it. There were 11 casualties, including all 6 of the bomber crewmembers. This aerial photograph was taken shortly after the accident and shows smoke billowing out of the large apartment building behind the brewery. (Seattle Public Library.)

Sick's Select was introduced in bottles in 1939. It was originally advertised as premium American table beer. At the time, Emil Sick proclaimed that the beer was "the realization of my ambition to brew a bottled beer that would be finer than any on the market." (Author's collection.)

66

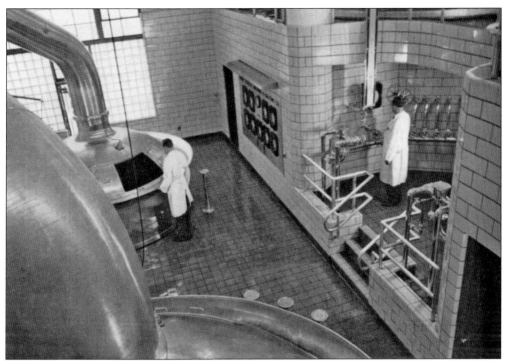

Seen here is Rainier Brewing Company's brew house as it appeared in 1951. Emil Sick realized shortly after World War II that the industry was moving more towards consolidation, making it harder for his smaller breweries to survive. In an effort to focus and expanded his Rainier Brewery in Seattle, he sold his Montana breweries in 1949, followed by the Salem plant in 1952, the Century plant in 1957, and the Spokane brewery in 1962. (Seattle Public Library.)

This series of photographs from 1951 shows the unloading and placement of one of Rainier's dozen new glass-lined fermentation tanks built by the Pfauder Company of Rochester, New York. Each one was 26 feet long, 10 feet tall, and weighed 25,000 pounds. (Author's collection.)

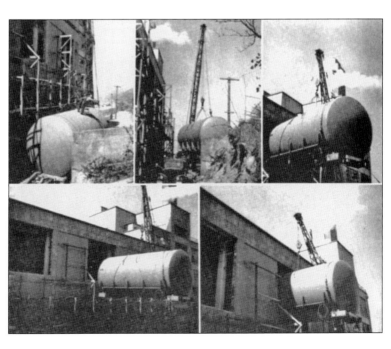

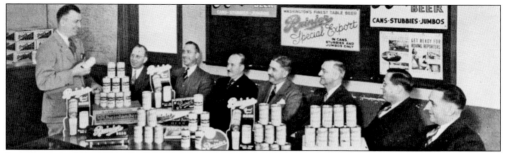

In 1934, nearly 75 percent of all sales were draft beer out of kegs, while 25 percent was packaged in bottles and cans. By 1949, these percentages were nearly reversed with 71 percent of all beer being packaged. With more people enjoying beer at home, tavern owners saw a steady decline in business. Rainier started an innovative tavern campaign in 1952 to help combat the problem and create brand loyalty among tavern owners. This mid-1940s photograph shows Arnold Wark explaining Rainier Beer talking points to the brewery's salesmen. (Seattle Public Library.)

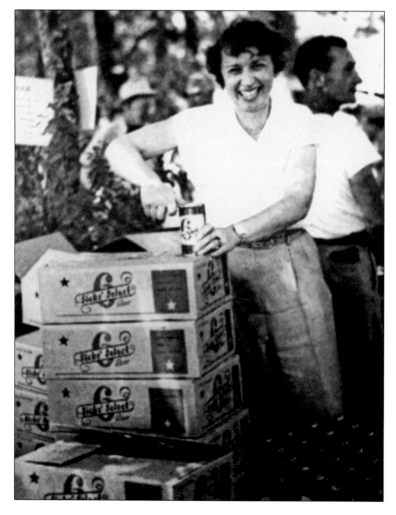

This 1950s photograph shows a happy Rainier employee opening up a can of Sick's Select during one of the many company picnics. (Seattle Public Library.)

This early-1950s photographs shows Rainier Brewery worker Earl Lindsay handling a wooden keg of beer. Aluminum began to replace the traditional wooden ones starting in 1946. The brewery's new aluminum kegs are seen in back. The change would cost thousands of coopers their jobs as breweries eliminated their cooperage shops. (Author's collection.)

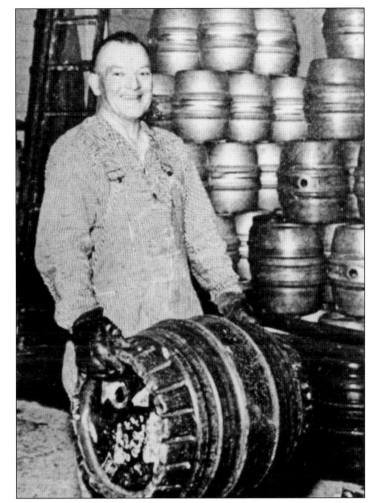

A 1946 group shot of Rainier's shipping department is pictured in front of the brewery's "pine room." (Author's collection.)

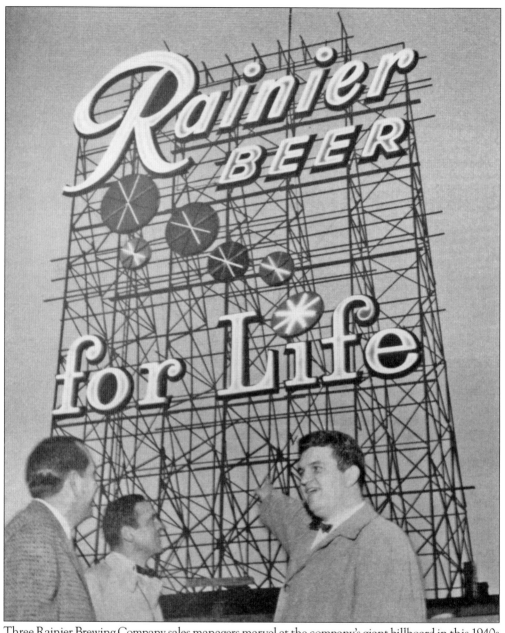

Three Rainier Brewing Company sales managers marvel at the company's giant billboard in this 1940s image captured in Portland, Oregon. The neon sign was 75 feet tall. (Author's collection.)

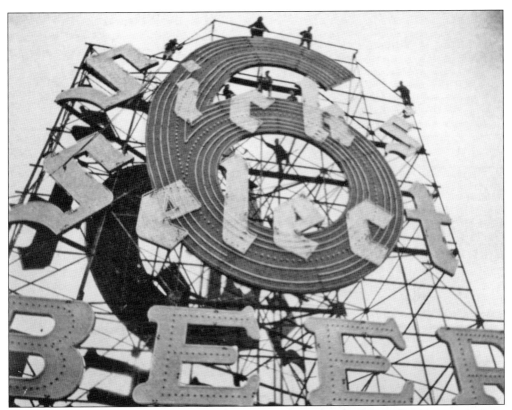

Rainier Brewing Company erected a number of creative advertising billboards in the mid-1940s, including this one for Sick's Select Beer. (Author's collection.)

Walt Tarley of Cammarano Bros. Distributors unloads a case of Rainier Beer in this 1958 photograph. Cammarano Bros. was Rainier Brewing Company's Tacoma-area distributor for decades. (University of Wisconsin, Steinbock Library.)

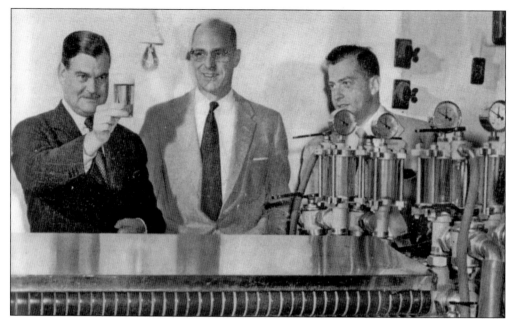

Rainier brewmaster Albert E. Bush (center) looks on as a man exams the results of Rainier's new sheet filter equipment. Bush served as Rainier's brewmaster from 1950 until the mid-1960s. In 1961, he, along with Rainier Brewing Company's technical director Nick Vacano and brewmaster Finn Knudsen, were granted a patent for a new kind of fermentation tank they invented and designed for the company. The style of tank is still widely used by today's craft breweries (Author's collection.)

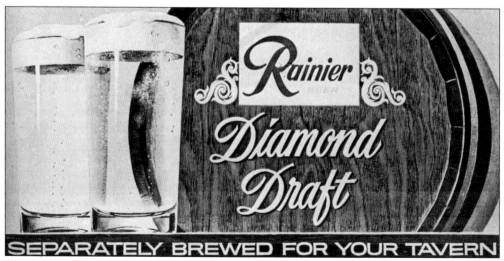

This billboard from 1957 advertises Rainier Diamond Draft, a beer brewed to commemorate the company's 75 years of brewing. (Author's collection.)

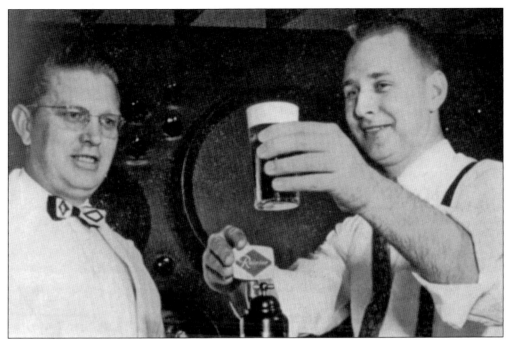

Ray Castle (right) conducted Rainier's draft beer course in the Mountain Room during the 1950s. He was hailed by *Allied Food & Beverage* magazine as 1956 Tavern Man of the Year. (Author's collection.)

Rainier hired San Francisco–based Landor and Associates in 1953 to create a new corporate identity. The advertising agency was started by brand pioneer Walter Landor in 1941. During his lifetime, Landor created many of the world's most recognized logos and identities, and his work for Rainier forever changed the company, both aesthetically and financially. (Landor Associates.)

The Rainier R, designed by Landor, became an iconic symbol for people living in the Pacific Northwest. Thanks partially to the success of Rainier's rebranding, Landor and Associates became one of the 20th century's most recognized and often-used agencies in the American beer industry. Over the years, the agency has worked with more than 30 American breweries. (Landor Associates.)

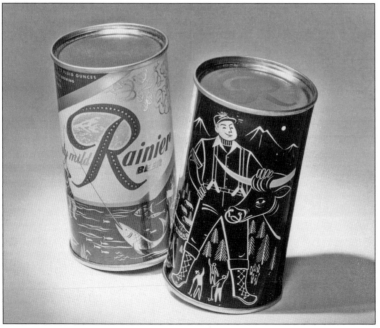

Also, at Landor's suggestion, Rainier introduced the Jubilee series of cans, starting with its Christmas cans in 1953. (Landor Associates.)

74

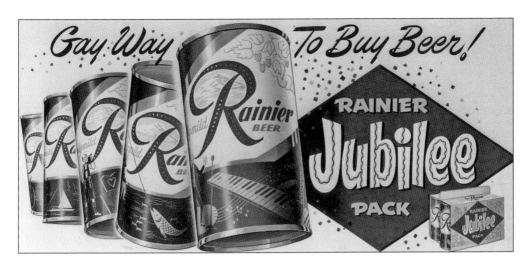

Pictured above is a 1953 billboard for Rainier Jubilee cans. Between 1953 and 1957, Rainier released four different Jubilee series with a total of 30 different designs. The 1956 cartoon series of Jubilee cans featured artwork by many of the era's top cartoonists, including Robert Osborn, Bob Cram (who began his run as Seattle's cartooning weatherman at King-TV in 1963), and William Steig (who later went on to create the Shrek character used in the series of movies by DreamWorks). The surviving cans from the Rainier Jubilee series are now highly sought after collector items. Certain cans from the series can fetch well over $1,000 in today's market. (Both, Landor Associates.)

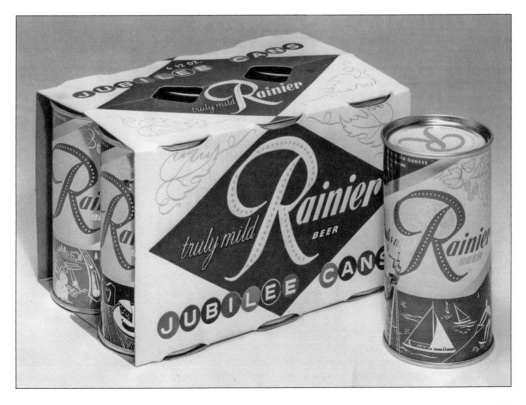

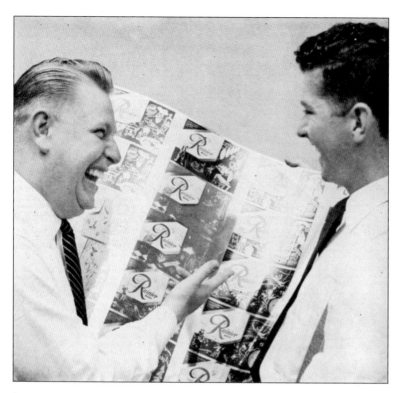

In this 1954 publicity shot, two Rainier Brewing Company executives show off an uncut metal sheet of Rainier Jubilee cans. Within a few years of introducing the cans, sales of Rainier six-packs increased by over 100 percent. (Author's collection.)

By the 1950s, Rainier's success warranted a series of expansions and modernizations to the brewery. In 1955, the packaging departments was at capacity, producing over 127 million units of packaged beer. Construction of a new $2.5 million packaging center started that same year and was completed in August 1956. This photograph shows a Rainier semi parked in front of the new center. (Seattle Public Library.)

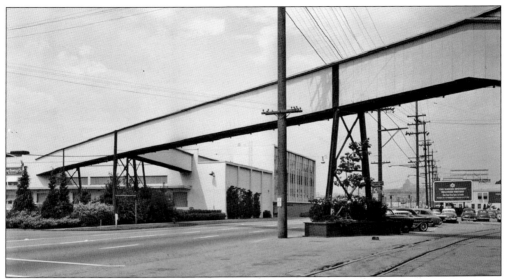

For logistical reasons, Rainier Brewing Company chose to build the packaging center directly across the street from the brewery. It then constructed an overhead bridge that ran from the brewery over Airport Way South and into the packaging center. Beer was pumped from the main brewery in large pipes that ran through the bridge and into the packaging center's "government cellar," where the beer was stored in 11 specially lined tanks each holding 98,000 gallons. (Seattle Municipal Archives.)

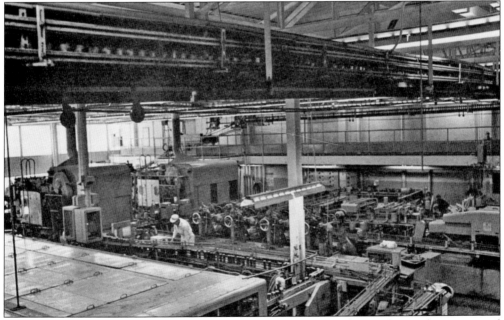

The ground floor of the new packaging center housed the new production line and was equipped with the most modern packaging equipment, including an automatic can unscrambler, can elevators, soaking and jet compartments of a new bottle sterilization machine, and bottle uncasing units. Twelve ounce cans were now able to be filled at a rate of 550 per minute while bottles could be filled as much as 420 per minute. This photograph of the packaging department was taken in 1969. (Author's collection.)

The warehouse section of the packaging center provided 37,000 square feet of usable floor space and could store 400,000 full bottles or cans of beer. In addition to the 10 dock ramps on the south end of the structure, railroad tracks along the side of the building allowed for easy shipping and receiving of materials. On busy days, up to 100 trucks could be handled on a single shift. This 1964 photograph shows the aforementioned shipping dock. (Washington State Archives.)

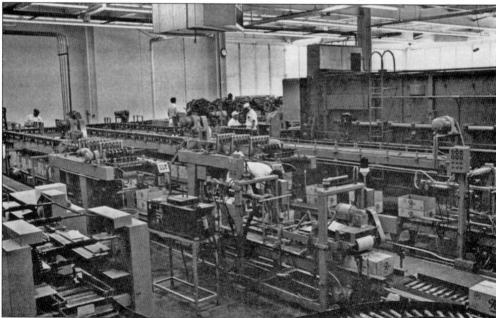

A 1960s photograph shows the packaging department. "This constantly growing sales demand has made it a vital necessity to step up Rainier beer and ale canning and bottling capacity by fifty percent," Emil Sick was quoted as saying at the time of the center's opening. The brewery also installed a state-of-art RCA Beer Inspecting Machine that provided electronic inspection of bottles going down the line at a speed of up to 450 per minute and automatically rejected any bottles with imperfections or chips. (Author's collection.)

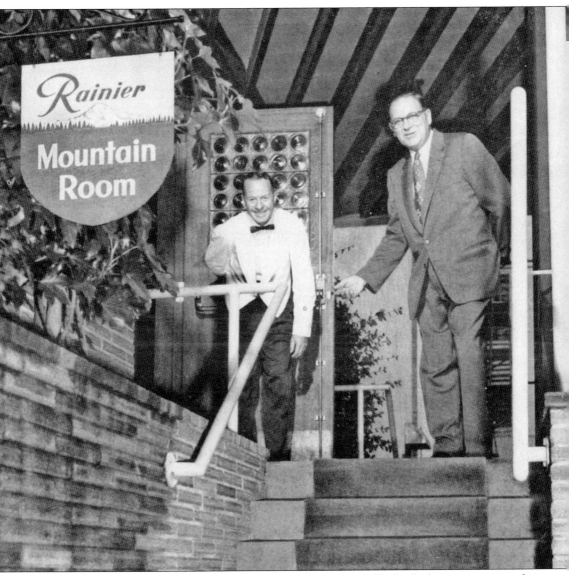

Rainier Brewery's Mountain Room was a popular taproom enjoyed by both the community and its employees. In this promotional 1954 photograph, visitors are greeted by friendly Mountain Room host Dave McLean (right) and bartender Bill Stebbins. (Author's collection.)

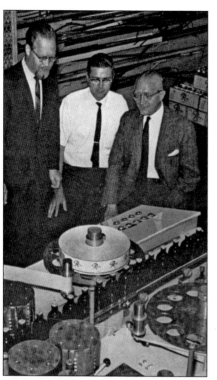

Rainier executives observe their new LB-350 beer bottle labeling machine. The machine was installed in 1968 and made by Akerlund & Rausing. Considered state of the art in its day, it was one of the first machines to feed from a giant roll of 25,000 labels instead of the precut stacks that had been the industry standard. It was capable of labeling at a speed of 600 bottles a minute and was used 15 to 18 hours a day once installed in Rainier's packaging department. (Author's collection.)

In an effort to increase sales and maintain informal professionalism, Rainier Brewing Company opened its new training center in 1967. The innovative center was the training grounds for the brewery's marketing, sales, and merchandising employees and featured a reception room, an administrative office, a tavern room, a grocery room, and an idea center. It allowed employees to learn the best way to market and sell Rainier Beer in simulated real-life situations. This 1967 photograph shows the simulated grocery section of the training center. (Author's collection.)

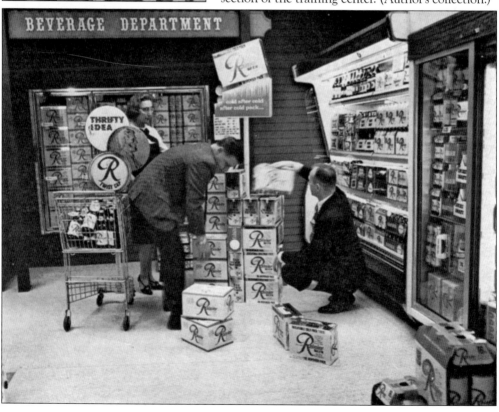

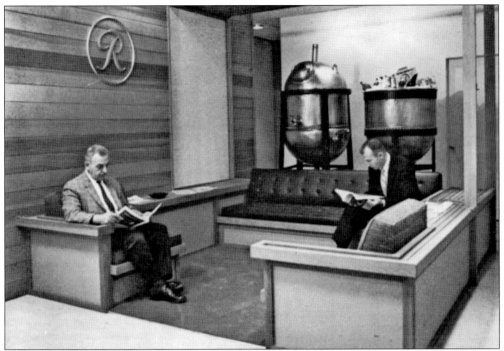

Men sit in the waiting room of the new training center in this 1967 photograph. The two kettles behind them were once used in the Hemrich breweries for the process of making near beer during Prohibition. (Author's collection.)

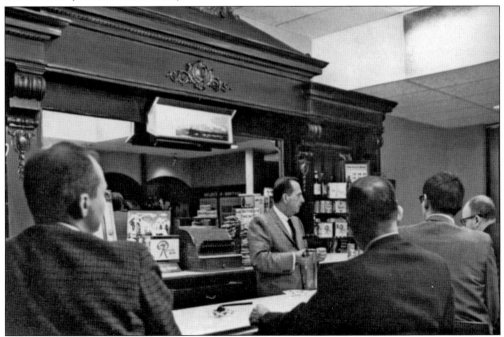

As seen in this 1967 image, the Rainier training center even featured a simulated tavern, complete with an antique bar and a functioning back bar. The center was masterminded by Murray Luther, Rainier's sales training manager. (Author's collection.)

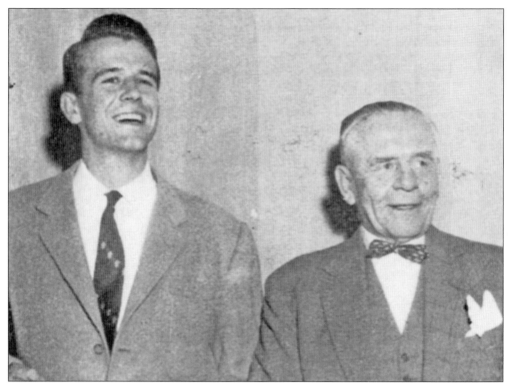

Pictured here in 1956 is Emil Sick with his son Tim. On November 11, 1964, Emil died at the age 70. Much more then just the owner of a brewery and baseball team, he was a humanitarian, a civic booster, and one of Seattle's greatest citizens. His many civic accomplishment included serving as president of the Seattle Chamber of Commerce, chairman of a nondenominational committee that raised funds to save St. Mark's Cathedral, and president of the Seattle Historical Society, which led a drive to build the Museum of History and Industry under his leadership. (Author's collection.)

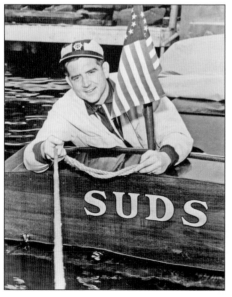

Alan Ferguson enjoys time on his boat *Suds* in this 1956 photograph. Just because he was the adoptive son of Emil Sick, there were no free rides for Ferguson at his breweries. Over the years, Sick had him work in nearly every blue-collar area at the breweries. Ferguson later said, "Ninety percent of the work in a brewery is keeping it immaculately clean. I scrubbed tanks. I scrubbed more floors and more tanks." In 1946, he left to serve in the Army, rising to rank of second lieutenant. Upon his return, he attended the University of Washington, graduating with a bachelor of arts in economics. He then went on to attend the Siebel Institute of Technology in Chicago, training as a professional brewmaster. (Ferguson family.)

Alan Ferguson is at home with his son in this 1956 image. At the age of 26, Ferguson, married and father of two, was told by doctors that he had cancer and only six months to live. By this time, Ferguson was well on his way to a successful career in the brewing industry, having risen to position of assistant general manager at Sick's Century Brewery. Devastated, he told Emil Sick the unfortunate news. Sick bluntly replied, "I don't believe it," and then promptly promoted Ferguson as executive vice president and general manager of the Rainier Brewing Company. After undergoing extensive hospital treatments in both Seattle and New York, Ferguson rid himself of the cancer and made a full recovery. Twelve years later, after once being given just six months to live, Ferguson became president of the Rainier Brewing Company. During his lifetime, he continued Sick's strong civic commitments to Seattle. He was prime minister of the 1956 Seafair, head of the Seattle-King County Convention and Visitors Bureau, and served as trustee of the Seattle Urban League. Ferguson died in 1993 at the age of 66. (Ferguson family.)

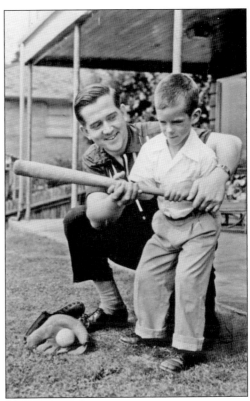

This photograph shows Ferguson in front of the Rainier Brewery in 1968. In 2012, Beanie Ferguson O'Neill, daughter of Alan Ferguson, remembered her father: "I adored my dad. He was a bright, kind, generous, funny and caring man who also loved to jitterbug, play the drums and paint landscapes. He taught me about honor, integrity, honesty and responsibility by living them every day. He was truly interested in people, took great joy in helping others reach their potential and was always looking for things to do that were positive. I miss him every day." (Ferguson family.)

Many were surprised to learn that Rainier Brewing Company played a large role in the emergence of the California wine industry. In 1967, Rainier Brewing Company was looking to diversify its investments. Alan Ferguson was put into touch with Robert Mondavi, then a struggling winemaker looking for capital. With Rainier's financial investment, Mondavi was able build his wine empire to unprecedented heights and forever change the American wine industry. (Robert Mondavi Winery.)

In this 1974 company photograph, the gritty Rainier Beer and the elegant Mondavi Fume Blanc live in perfect harmony next to one another as they seemingly break bread in the middle of a Napa Valley wine field. "Rainier was an amazing partner for us," Mondavi later said. "It was a deal made in heaven." (Seattle Public Library.)

Jazz music was also an interest of Rainier president Alan Ferguson. In the late 1960s and early 1970s, Rainier teamed up with the Seattle Jazz Society to sponsor a number of free jazz concerts in the city. The pinnacle of involvement was the main sponsorship of the Northwest Jazz Spectacular in October 1970. The two-day event at the Seattle Center Arena attracted over 8,500 people and featured Miles Davis, Herbie Hancock, and Roberta Flack, among others. (Author's collection.)

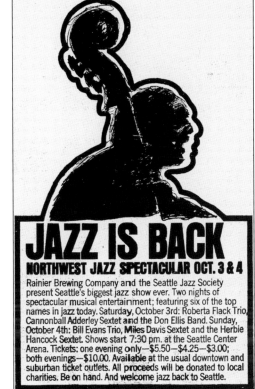

JAZZ IS BACK
NORTHWEST JAZZ SPECTACULAR OCT. 3 & 4

Rainier Brewing Company and the Seattle Jazz Society present Seattle's biggest jazz show ever. Two nights of spectacular musical entertainment; featuring six of the top names in jazz today. Saturday, October 3rd: Roberta Flack Trio, Cannonball Adderley Sextet and the Don Ellis Band. Sunday, October 4th: Bill Evans Trio, Miles Davis Sextet and the Herbie Hancock Sextet. Shows start 7:30 pm. at the Seattle Center Arena. Tickets: one evening only—$5.50—$4.25—$3.00; both evenings—$10.00. Available at the usual downtown and suburban ticket outlets. All proceeds will be donated to local charities. Be on hand. And welcome jazz back to Seattle.

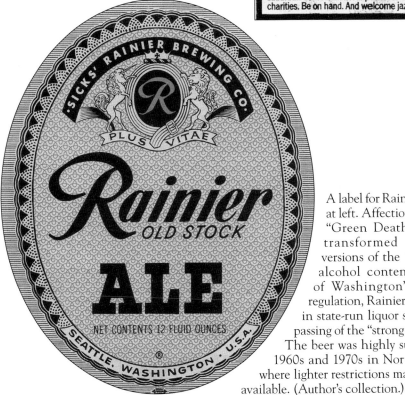

A label for Rainier Ale is pictured at left. Affectionately nicknamed "Green Death," the beer was transformed from mellower versions of the 1930s into a high alcohol content beer. Because of Washington's strict alcohol regulation, Rainier Ale was only sold in state-run liquor stores prior to the passing of the "strong beer law" of 1982. The beer was highly successfully in the 1960s and 1970s in Northern California, where lighter restrictions made it more widely available. (Author's collection.)

This photograph, featured in Rainier's 1969 annual report, shows that although marketing department meetings at Rainier could be stressful at times, employees could at least spend most of the meeting drinking Rainier Beer and smoking cigarettes. (Seattle Public Library.)

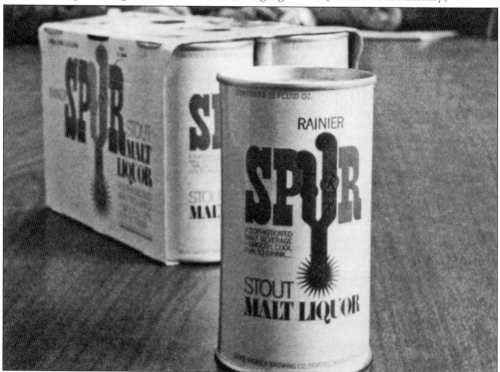

Rainier Spur was the company's entry into the emerging malt liquor segment of the industry and was first test marketed in 1966 in Southern California. Early advertisements for Spur featured popular singer Lou Rawls. The beer never gained much traction and likely suffered from limited availability in Washington. (Author's collection.)

Rainier Bold Malt Liquor came out soon after Spur's demise. The menacing silhouette of a rearing unicorn solidified the bold theme of the malt liquor, but it was not enough to convince consumers. The beer was discontinued a few years later. (Author's collection.)

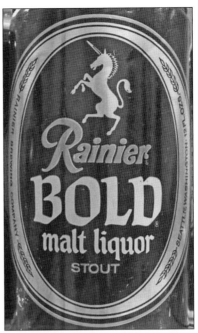

In 1968, after 32 separate market research studies, Rainier revealed a dramatic new marketing strategy it called "the Three Beer Concept." Rainier Beer was now available in three new variations: Light-Light (a crisper version of Rainier), Light (repackaged original Rainier Beer), and Not-So-Light (a more robust beer). By all accounts, the concept was a disaster. It confused most beer drinkers who just wanted to drink regular Rainier Beer, and overall sales of the brand decreased. The concept was scrapped completely a few years later. Not-So-Light briefly lived on under the new name, Rainier Hearty Lager. (Seattle Public Library.)

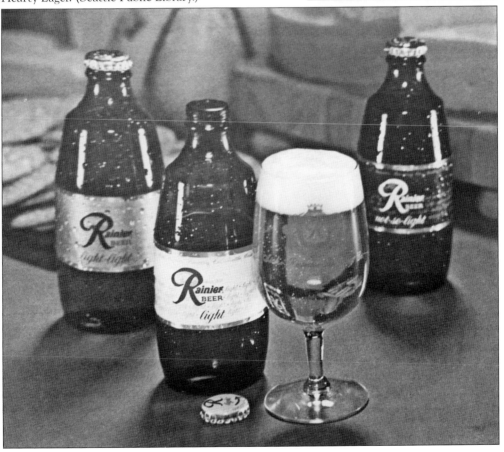

The Rainier brewmaster was a fictional mascot used by the Rainier Brewing Company starting in 1965. In the advertisements, the brewmaster was a stubborn character who often went to great lengths to bring the people of the Pacific Northwest the smoothest Rainier Beer possible. (Author's collection.)

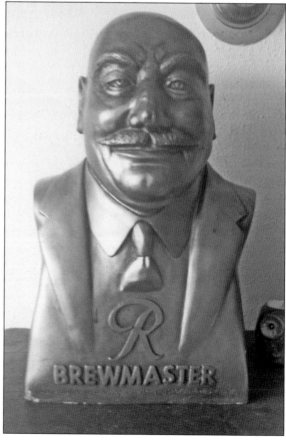

In 1965, Rainier Brewing Company produced a limited number of busts of its popular brewmaster advertising figure. The bust mold was made by 18-year-old Frank Somer of Powell, Wyoming, and manufactured by the Tili Mac Handicraft Company. They were mainly distributed to taverns, where some can still be found today. (Author's collection.)

Tour guide Sandy Nishio leads a group of visitors in 1969 on the popular Rainier Brewery tour. Thousands of Seattle residents and visitors took the tour each year. Visitors ended their tour with a free glass of beer in Rainier's Mountain Room. (Seattle Public Library.)

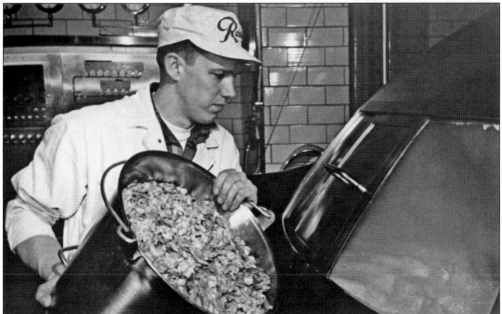

A Rainier Brewing Company employee adds fresh hops to the brew kettle in this 1969 photograph. In 1971, Rainier was the country's 25th largest brewery with an annual output of 835,000 barrels of beer. (Seattle Public Library.)

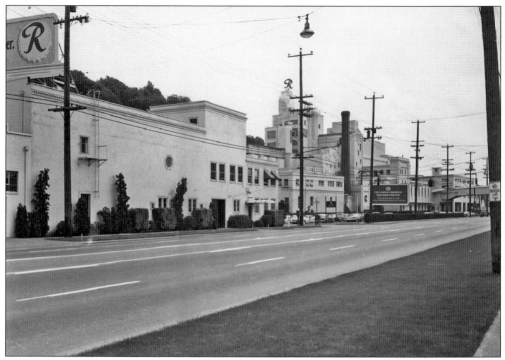

The big R was installed atop the Rainier Brewery in 1954. For 13 years, the iconic symbol rotated in circles as it flashed until, for safety's sake, the sign became stationary in 1967 after the completion of Interstate 5. (Seattle Municipal Archives.)

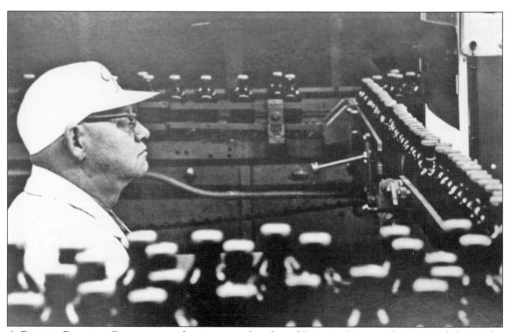

A Rainier Brewing Company worker inspects bottles of Rainier Beer as they moved down the line in 1968. (Seattle Public Library.)

By 1977, Rainier Brewing Company was the 14th largest brewery in the United States. This photograph shows a panel board for the fully automated beer filtration system that was installed at the Rainier Brewery in the late 1960s. (Author's collection.)

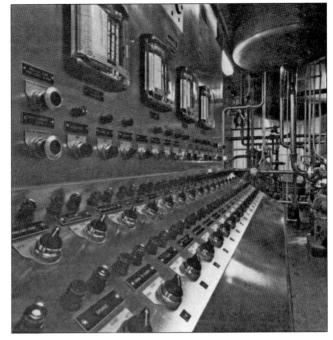

In 1978, Rainier Brewing Company celebrated its "beercentennial," commemorating 100 years of brewing. The "Since 1878" tagline proved to be a total fabrication by Northwest beer historian Gary Flynn, who points out that the year was merely a catchphrase first used in the early 1930s by the Rainier Brewing Company of San Francisco. Rainier's true origin was either in 1883, when Hemrich & Kopp built a brewery on the site of the future Rainier Brewery, or 1893, when Rainier Beer was first brewed by the Seattle Brewing and Malting Co. This photograph shows a special retrospective bottle of Rainier Beer sold in 1978 to commemorate the company's beercentennial. (Seattle Public Library)

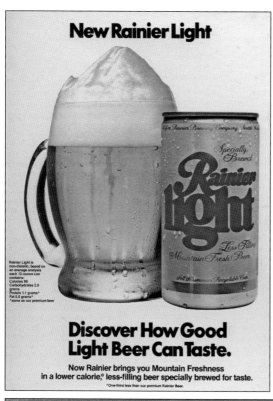

Rainier Light came to market in April 1977. Modern light beer was invented by biochemist Dr. Joseph Owades in 1967 when he used the enzyme amyloglucosidase to convert starches and unfermentable sugars to fermentable forms. The yeast then converts the sugars to alcohol, creating an alcoholic beer with low calories. Bud Light, introduced in 1984, is currently America's best-selling beer. (Author's collection.)

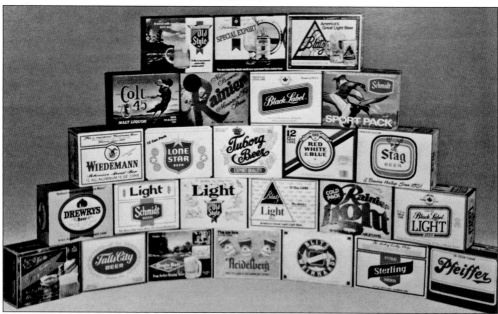

Rainier Brewing Company was acquired by the G. Heileman Brewing Company in 1977. Heileman rose to become one of the nation's largest beer companies by the 1980s after acquiring a large number of popular regional brands throughout the United States. Other popular Pacific Northwest beers, such as Blitz-Weinhard and Heidelberg, were also in the company's portfolio at one time. This photograph shows the complete Heileman line up in 1978. (Wisconsin Historical Society.)

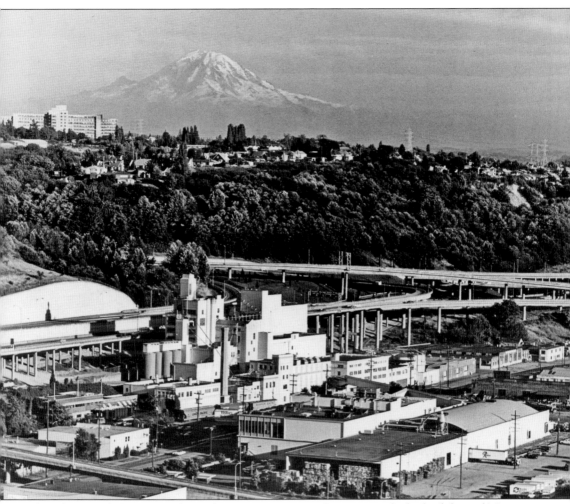

This photograph from 1978 shows the Rainier Brewing Company with the backdrop of Mount Rainier. In 1996, Rainier Brewing Company was acquired by Stroh Brewing Company. Rainier Beer was added to the stable of other established beer brands owned by Stroh's, including Colt 45, Mickey's, and Schlitz. In February 1999, Stroh president John Stroh II announced the company was ending its 149-year run in the brewing industry after suffering a staggering drop in overall sales. Its brands were sold to Pabst Brewing Company and Miller Brewing Company. The sale cemented the end of Rainier Beer in Seattle. (Seattle Public Library.)

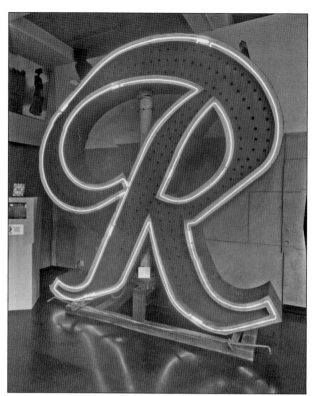

Pabst Brewing Company purchased the Rainier label and ended its production at the Seattle brewery. Rainier was contract brewed in the old Olympia Brewery in Tumwater, Washington, for a few years before production switched to Irwindale, California, where it is still brewed today. This photograph shows the iconic *R* that graced the top of the Rainier Brewing Company for 55 years. The item was donated to the Museum of History and Industry in Seattle, where it rested comfortably in the museum's gift shop. In 2012, the "R" was restored and moved to the museum's new South Lake Union location. (Author's collection.)

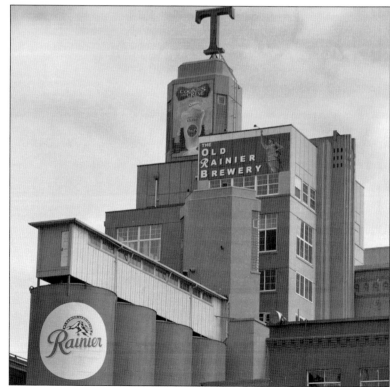

Pictured here is Old Rainier Brewery as it looks today. It is now the headquarters of Tully's Coffee. The Rainier *R* has been replaced by Tully's *T*. (Russell Lo.)

Five

THE WILD RAINIERS!

Rainier Brewing Company cemented its product forever in the hearts of the people of Washington in the 1970s by simply hiring a new advertising agency.

By 1970, Rainier Brewing Company was in trouble. The yearly sales gains it experienced during most of the 1960s had vanished, and by the early 1970s, Olympia Beer was the top-selling beer in Washington, with Rainier falling to a distant sixth. So when two guys in their mid-1920s walked into Rainier's boardroom and started pitching bizarre and unconventional advertising proposals, many of the seasoned Rainier executives must been more then a little bewildered. The ideas pitched that day were strange to say the least, but they struck a chord, and the timing was perfect. The brewery had hired three different advertising agencies in the past five years, only to see its sales continue to plummet. The company knew they needed go in a different direction, however odd these new ideas seemed.

So the Heckler-Bowker agency (later Heckler Associates) was hired, and with Rainier's Seattle future uncertain, the two men, both with zero experience in the beer industry, almost single-handedly turned the company's fortunes around. A year after they became Rainier's full-time advertising agency, Rainier was once again the best-selling beer in Washington, and its commercials and print advertisements forever changed the way beer was advertised.

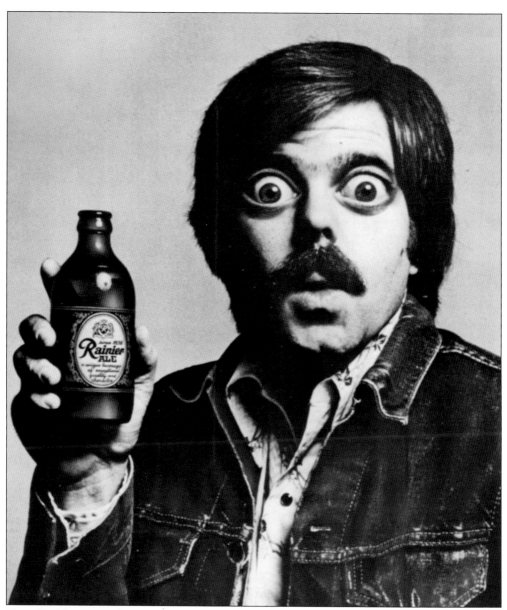

Terry Heckler majored in graphic design at Carnegie Mellon. He did computer graphics for Boeing for a few years before becoming the art director for *Seattle* magazine. His business partner, writer Gordon Bowker, a graduate of the University of San Francisco, later went on to cofounded both Starbucks and Redhook Brewing Co. Rainer first hired Hecker Associates on a probationary-style basis. Its first advertisement was for Rainier Ale and featured this straight-on shot of a man with eyes oversized just enough to entice the reader for a second look. (Heckler Associates.)

Rainier executives liked what they saw and officially hired the agency. That same year, Heckler proposed a series of television commercials for the brewery. Rainier had never done much television advertising and was weary of the idea, while Heckler Associates had zero experience with commercials altogether. The proposal was somehow approved, and what the agency created was a series of commercials that changed the entire landscape of how the industry marketed its beer. Soon, Rainier was seeing unprecedented growth. Gordon Bowker left the company a few years later to commit more time to Starbucks. (Heckler Associates.)

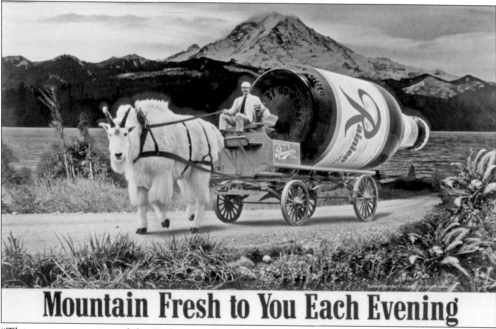

Mountain Fresh to You Each Evening

"This was our version of the Budweiser Clydesdales pulling their beer wagon that we originally substituted with a team of mountain goats pulling a Rainier wagon. St. Louis didn't see the humor in it and sent their wagon of lawyers after us. So, we came up with this way different version that they still didn't see the humor in," Terry Heckler explained in 2012. (Heckler Associates.)

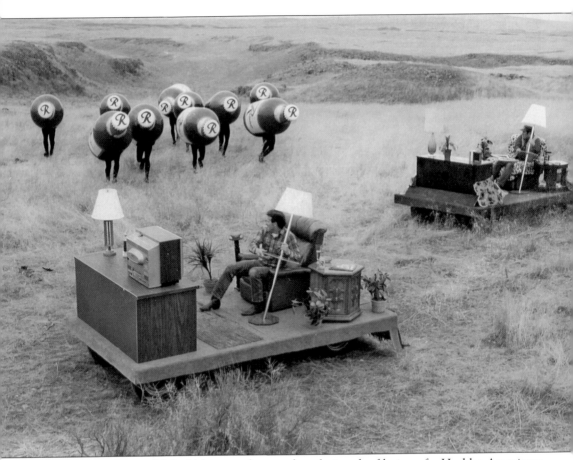

This previously unpublished photograph was taken during the filming of a Heckler Associates Rainier commercial. While St. Louis did not originally see the humor in the advertisements, they quickly took notice to the success Rainier was experiencing airing them. Many breweries tried to emulate the company, while others even recycled its ideas. The famous Budweiser commercial, for example, where three frogs croak out "Bud-wei-ser" reminded many Northwest beer drinkers of a Rainier commercial almost 20 years prior that centered around frogs croaking, "Rain-ier." (Heckler Associates.)

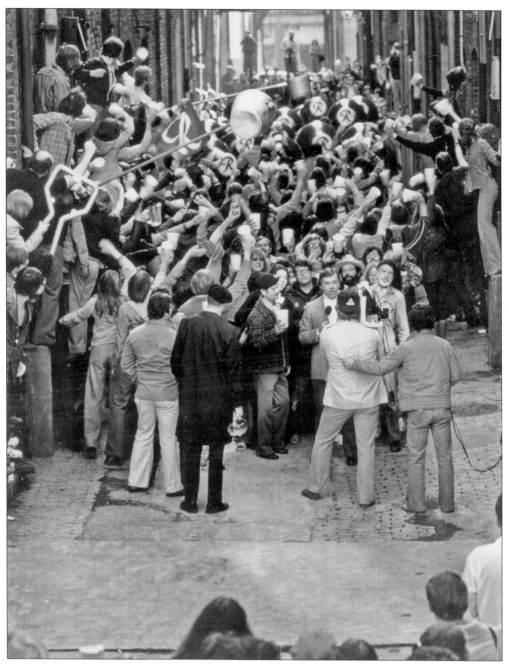

According to Terry Heckler in 2012, "This [photograph] shows the Bumbershoot crowd we highjacked to an alley in Pioneer Square to film the 'Running of the Wild Rainiers' commercial. The event was repeated in several cities until the brewery shut it down when we worked out details to run them in Pamplona." (Heckler Associates.)

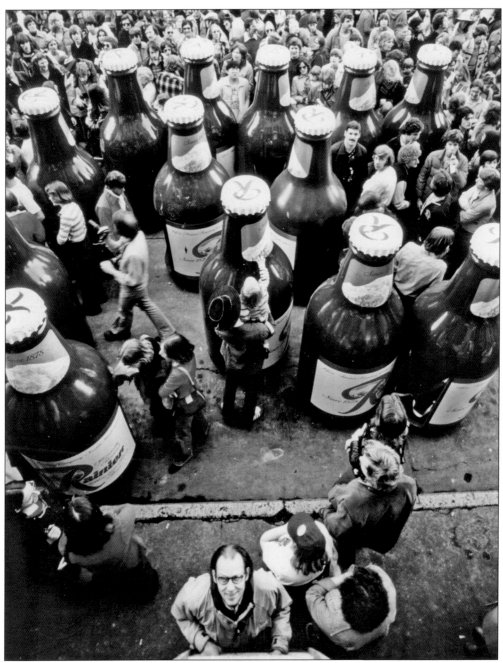

Heckler Associates created over 275 television commercials in its time with Rainier Brewing Company, not to mention hundreds of Rainier magazine, newspaper, and radio advertisements and package redesigns. In 1982, the agency also started working with the start-up Redhook Brewing Co., creating all of its original logos, packaging, and advertisements for the next 20 years. This candid image was captured during the production of one of the advertisements. (Heckler Associates.)

Hollywood screen legend Mickey Rooney was hired to do a series of commercials and print advertisements for Rainier starting in the late 1970s. Today, at age 92, Rooney has had the longest career of any actor in Hollywood history, steadily acting in films for over 85 years in 10 different decades. This photograph was taken during one of Rooney's spots that Terry Heckler recalled in 2012. "We wanted to do an adventure TV ad series on hunting the Wild Rainiers, teaming up a local sports celebrity with a national celebrity. This one featured [heavyweight boxer] Boone 'Boom Boom' Kirkman with Mickey Rooney. Mickey seemed to enjoy our seriousness and did seven different Rainier spots with us. I showed these spots to my dad, and he never believed we did them." Mickey Rooney also reminisced about his time with Rainier with the author in 2012: "I was already in Seattle doing a play about alimony called *Three Goats and a Blanket* when I was approached to do the Rainier Beer commercials. I especially remember the two commercials tracking through the jungle and braving the rapids. I worked with professionals and had a lot of fun. I remember that the beer was incredible too!" (Heckler Associates.)

Think Fresh

Rainier Brewing Company, Seattle, Washington

This early Heckler-Bowker's advertisement featured local Seattle visual artist Chris Kirk, who later admitted he was a little overwhelmed and embarrassed by all the attention it caused him. "That's what happens when your wife works for the ad agency," he said. "They didn't tell me what they were going to do with the picture; just that it would show up in a lot of places." Terry Heckler remembers the advertisement being "our answer to the brewery's request to do a poster showing the beer and Mt. Rainier." (Heckler Associates.)

Pictured here is a promotional Wild Rainier figure. Stickers, coffee mugs, pins, posters, shirts, hats, and inflatables were all created using the popular Rainier mascot. (Heckler Associates.)

This previously unpublished photograph shows the running of the Wild Rainiers during the filming of a Rainier commercial. Terry Heckler is now semiretired but still works in his Belltown office a few times a week. In addition to his work with Seattle breweries, he designed many of the most recognizable brand identities and logos of the time, including those of Starbucks, Cinnabon, Panera Bread, and New Balance. Although history may forever associate these advertisements with Terry Heckler, it took a small army of creative and innovative locals to craft them over the years. Two key people who were major creative forces behind the advertisements and also deserve a lot of recognition are Ed Leimbacher, the official writer-producer for all of the Rainier advertisements from 1973 to 1985, and Gary Noren of Kaye Smith Productions, who directed many of the spots. Without these two, many of the most memorable Rainier commercials and ideas would never have been created. (Heckler Associates.)

Six

Redhook and the Rise of Craft Brewing

Two separate events occurred in Washington state on a single day in April 1982 that had lasting effects on the American brewing industry.

In Yakimia, Washington, a Scotsman by the name of Bert Grant opened the doors to what was the first brewpub in the United States since Prohibition. Grant's Brewery Pub reestablished a business model that helped nurture craft brewing into what it is today. Around 150 miles west, at about the same time Grant's was serving its first pint, Redhook Brewing Co. brewed its inaugural batch of beer in a recently converted transmission shop in Ballard.

Just opening a brewery was a major accomplishment, given the era. There were under 90 operating breweries in the United States in 1981. By 1983, there was only 51 brewing concerns operating a total of 80 breweries, a low watermark for the industry in the 20th century. So when Paul Shipman and Gordon Bowker set out to brew traditional English-style ales for the people of Seattle, eyebrows raised and many industry veteran's eyes rolled at the notion. New breweries just did not open back then—they only closed.

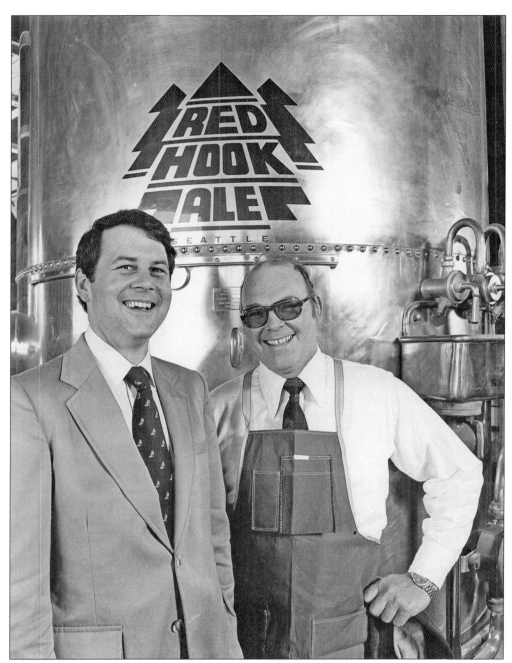

Pictured here is Paul Shipman and brewmaster Charles McElvey in 1982. Their first brewing equipment was made in the 1950s and acquired from a brewery in West Germany. The large brew house behind them, manufactured by Zieman, was a 25-barrel unit made of copper. "We later sold it to a group in Western Samoa, where it tragically was swept to sea in a typhoon. One of my all-time favorite stories," recalled Redhook's cofounder Paul Shipman. (Redhook Brewing Co.)

This 1981 photograph shows the inside of the former one-story automotive transmission shop shortly before it was remodeled to become Redhook's first brewery. The shop, located at the corner of Northwest Fourty-seventh Street and Leary Way, was ideal for the small brewery because of its high ceilings and large garage doors. (Redhook Brewing Co.)

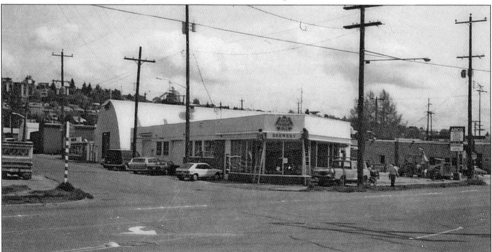

This is a photograph of the exterior of Redhook's first brewery in 1982. Twenty investors contributed a total of $500,000 for the creation of the company. It was Seattle's first new brewery since the 1930s. (Redhook Brewing Co.)

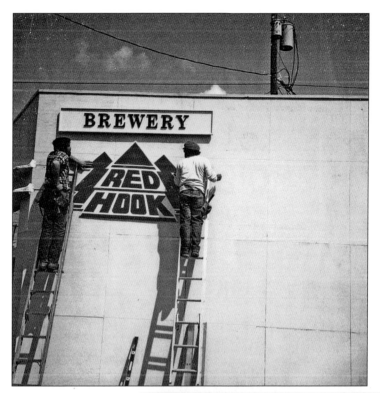

This 1982 image was captured during the installation of Redhook's original sign on the side of its first brewery. The man on the right is Regnor Reinholdsten, a Norwegian fisherman and well-known Seattle-area potter. Reinholdsten also designed and sculpted the original English-style clay tap handles Redhook used at its first bar and restaurant accounts. (Redhook Brewing Co.)

According to Redhook cofounder Paul Shipman in 2012, "This photograph shows the arrival of our first fermenter at the Ballard Brewery in 1982. From the left [are] our neighbor who managed a Boeing supplier store next door; Rick Buchanan, in plaid, was a plumber and brewer; Mark Marzano was delivery and sales and is now working for Deschutes Brewery; and Bob Zahler, a brewer who subsequently married Charlie McKelevy's daughter." (Paul Shipman.)

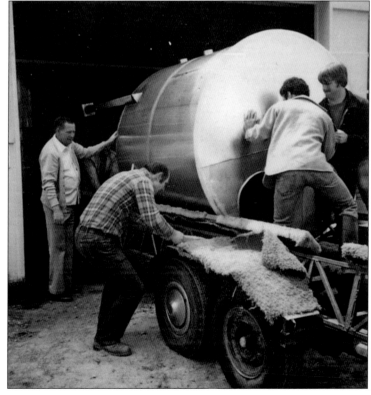

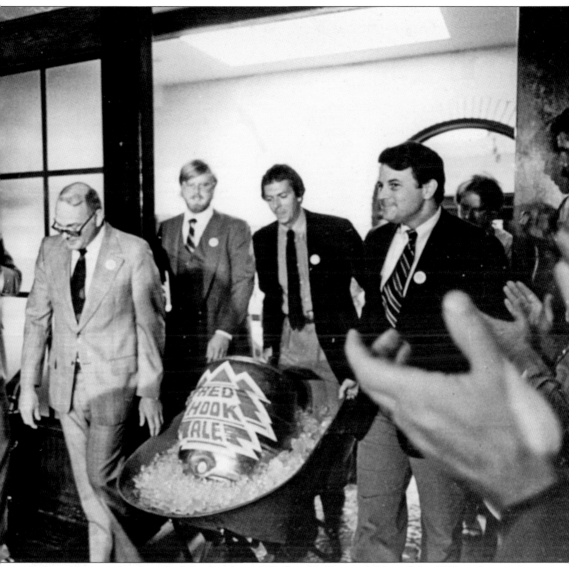

Pictured here is the arrival of the first keg of Redhook's Original Ale at Jake O'Shaughnessey's pub for Redhook's release party on August 12, 1982. From the left to right are original brewmaster Charles McKelevey, brewer Mark Daniels, delivery driver Tom Milner, and cofounder Paul Shipman. "Gordon Bowker orchestrated everything masterfully; from leads in every local television news show that night to the front page of the newspapers the next day," remembered Shipman. (Redhook Brewing Co.)

In this 1982 photograph, one of the first batches of Redhook Original Ale is being loaded for delivery. Redhook benefited greatly in 1982 when Washington changed the way beer could be sold Before the new change, any malt beverage above four-percent alcohol could only be distributed to restaurants and taverns through the Washington State Liquor Control Board and could only be sold on a retail level at state-run liquor stores. Redhooks first beer was at five percent and because of the change in law could now be sold throughout the region. (Redhook Brewing Co.)

Redhook introduced Blackhook Porter as its second beer in 1983, followed by Ballard Bitter in May 1984. Ballard Bitter, with a slogan that poked fun at Ballard's Scandinavian roots, established Redhook as a brewery. Much of the brewery's early successes and expansion can be attributed to the sale of this beer. Ballard Bitter was the brewery's top seller until 1990 when it was overtaken by Redhook ESB (Extra Special Bitter). Today, ESB continues to be the brewery's best-selling beer. (Author's collection.)

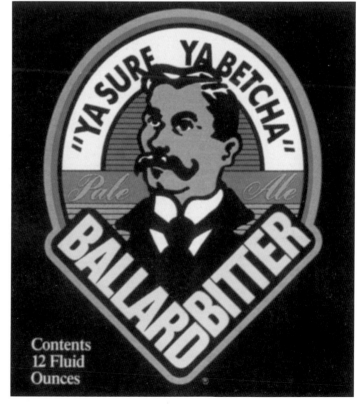

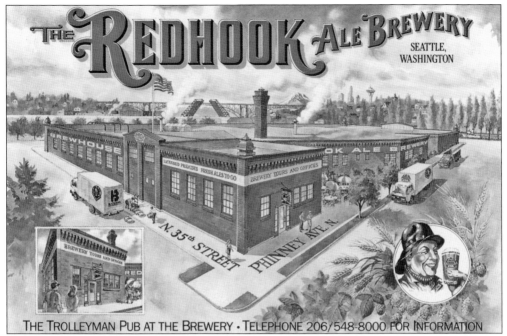

This promotional poster depicts Redhook's second Seattle brewery, located at 3400 Phinney Avenue North in Seattle's Fremont neighborhood. The success of Ballard Bitter pushed production of Redhook's original brewery to its capacity. In 1989, the company remodeled and then moved into a 26,000-square-foot trolley barn originally used by the defunct Seattle Electric Railway. After the move, Redhook enjoyed an annual capacity of 30,000 barrels. (Author's collection.)

Pictured is Redhook's keg line in 1990, located across the street from its Fremont brewery. "Expansion forced us across Phinney Avenue, where we occupied an old machine shop that connected to the brewery by underground tunnel. The line was manufactured by Till and was the most advanced in the United States for a craft brewer. We ultimately sold this line to Sierra Nevada in 1997," Paul Shipman recalled in 2012. (Redhook Brewing Co.)

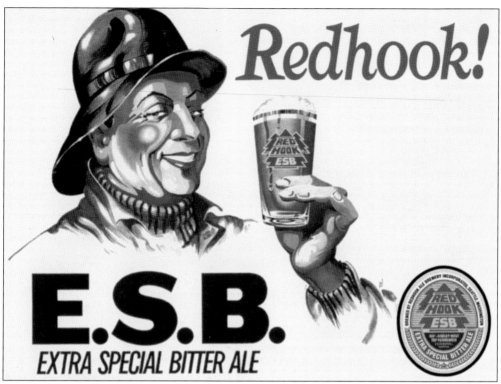

Redhook's phenomenal growth saw the opening of a much larger brewery in Woodinville, Washington, in 1994, and two years later, a third brewery was opened in Portsmouth, New Hampshire. By the end of 1997, Redhook's annual sales topped $40 million. Above is an advertisement for Redhook's Extra Special Bitter Ale. (Author's collection.)

Redhook's Trolleyman Pub was connected to its Fremont brewery and was a popular neighborhood gathering spot for many years. In 1998, Redhook stopped production at its smaller Ballard brewery, ending a remarkable 16 years of brewing in Seattle. Trolleyman Pub continued to operate after the brewery's demise, until it also eventually closed in September 2002. The sign shown in the photograph is now located inside Redhook's Forcasters Pub at its Wooinville brewery. The brewery itself is now home to Theo, an organic chocolate company. (Redhook Brewing Co.)

An entire book could be dedicated to the influence Charles Finkel and his wife, Rose Ann, have had over not just Seattle's brewing culture but the entire American craft brewing industry. Before establishing Pike Place Brewery in 1989, the two had already created America's first boutique wine importing business and later a beer importing company that first introduced America to many of the most popular beer styles in craft brewing today.

In 1989, Charles and Rose Ann Finkel bought the Liberty Malt Supply Co. with the thought of creating a microbrewery as a way to show home brewers how beer is made. Founded in 1921, it was one of America's oldest home brew stores. This photograph from 1974 shows the store in its original location in Pike Place Market. It later moved under the market in the LaSalle Hotel building at 1432 Western Avenue and served as Pike Place Brewery's first location. (Seattle Municipal Archives.)

Charles Finkel looks on as Franz Inselkammer taps the first keg of Pike Pale Ale in October 1989. Inselkammer is the longtime owner of the Aying Brewery, considered to be one of Germany's finest breweries. Inselkammer continues to be an influential figure for many of today's leading craft brewers. (Pike Brewing Co.)

Charles Finkel stands before Pike Place Brewery in 1990. Due to the space limitations of the original brewery, a four-barrel copper kettle was custom made by Seattle's Alaskan Copper and Brass Co., the same Seattle company made Horluck Brewing Co.'s fire-brewed kettle 50 years prior. (Pike Brewing Co.)

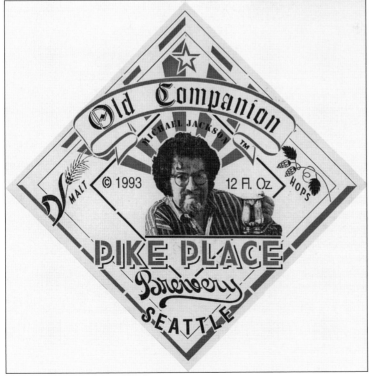

Pale Ale was soon followed by XXXXX Stout and Pike Kilt Lifter, a Scotch-style ale that continues to be the brewery's most popular beer. In 1992, the brewery commemorated influential beer writer Michael Jackson's 50th birthday by releasing Old Companion. (Pike Brewing Co.)

Pike moved to a new location next to the market in 1995 and changed its name to Pike Brewing Co. The current location is a multilevel brewery, pub, restaurant, and beer museum. Today, Pike Brewery Co. continues to thrive, recently celebrating its 20-year anniversary. The beers are currently distributed in all 50 states. (Pike Brewing Co.)

Pike Brewing Co. is now the third oldest independently owned brewery in Washington State. The microbrewery museum, located in the Pike's brewpub, is home to one of the largest collections of beer memorabilia in the United States. This recent photograph shows Tiffany Herrington packing bottles for shipment as they come off Pike's bottling line. (Pike Brewing Co.)

Mike Hale (right) stands before a early shipment of kegs to his Hale Ale Brewery. Mike Hale started brewing his English-style ales in Coville, Washington, in 1983. Hale's Ales were brewed in Kirkland and later Spokane before the opening of its current location in the Fremont/Ballard area of Seattle in 1995. Hale's Pale American Ale was the first microbrewed pale ale in the state of Washington. (Hale's Ales.)

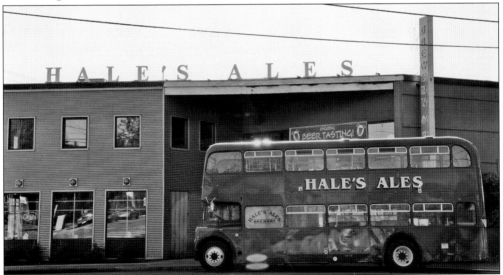

Hale's Ale's Brewery & Pub is a remodeled 17,000-square-foot building that was formerly an industrial hose manufacturing plant. The new brewery increased Hale's production capacity from 6,000 barrels a year to 20,000 and included an expansive pub that could seat up to 125. This recent photograph shows the refurbished Hale's Ales double-decker bus parked in front of its Seattle brewery. (Geoff Kaiser.)

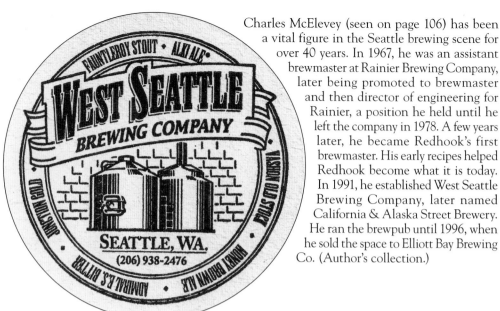

Charles McElevey (seen on page 106) has been a vital figure in the Seattle brewing scene for over 40 years. In 1967, he was an assistant brewmaster at Rainier Brewing Company, later being promoted to brewmaster and then director of engineering for Rainier, a position he held until he left the company in 1978. A few years later, he became Redhook's first brewmaster. His early recipes helped Redhook become what it is today. In 1991, he established West Seattle Brewing Company, later named California & Alaska Street Brewery. He ran the brewpub until 1996, when he sold the space to Elliott Bay Brewing Co. (Author's collection.)

Charles McElevey's next venture was the Pacific Rim Brewing Co. in White Center, where his beers the Admiral ESB and Alki Ale became favorites at many area pubs and restaurants. The brewery's Rat City IPA also gained a faithful following. Pacific Rim closed in December 2007, but McElevey continues to work as a brewery consultant in Seattle. (Paul David Gibson.)

Big Time Brewing Co. is Seattle's longest running brewpub, operating in the University District since 1988. The brewery offers as many as 12 beers at any given time at its University District pub and is renowned for its annual Old Wooly Barleywine offering. (Author's collection.)

Adam Merkl (left) and Ryan Hilliard (right) started Hilliard's Beer in the industrial area of Ballard in the fall of 2011. The brewery's flagship beer is Hilliard's Saison, a somewhat obscure style of beer available in 16-ounce aluminum cans (as seen in the large stacks behind them). Hilliard's Beer is also available on draft, both in its Ballard taproom and area taverns and restaurants. (Geoff Kaiser.)

Hart Brewing was established in 1984 in Kalama, Washington, by Beth Hartwell. In 1986, the brewery introduced Pyramid Wheaten Ale, the first wheat beer produced in the states since Prohibition. Beth later sold the brewery to five Seattle investors who moved the operations to Seattle in 1995. The next year, Hart Brewing officially changed its name to Pyramid Breweries after its best-known brand. Success brought major changes to the company over the next 15 years, including a series of expansions, public offerings, mergers, and acquisitions. In 2008, after shifting all of its brewing away from Seattle, Pyramid went through, for lack of better term, its "sports drink phrase." The names of its established beers were changed to Haywire, Thunderhead, and Audacious, and its label was changed to a collage of athletic people doing everything from rock climbing to surfing. In 2012, the beer was again rebranded with a more classic appearance, and a portion of its brewing was shifted back to Seattle. The label below is for one of the company's early Seattle beers. (Above, Ben McAllister; below, author's collection.)

Georgetown Brewing Company was started by friends Manny Chao and Roger Bialous in 2002. The brewery had an original capacity of 3,000 barrels and occupied a corner of the old Seattle Brewing & Malting Co.'s malting room. It was the first commercial enterprise to brew in the building since Prohibition. Its first beer, Manny's Pale Ale, remains the flagship beer and has been the most widely available craft beer in Seattle for years. In the summer of 2010, the company expanded into a new brewery with a capacity of 35,000 barrels a year (Ben McAllister.)

Maritime Pacific Brewing Company is a family-owned brewery established in the Ballard district of Seattle in 1990 by George and Jane Hancock. In 1997, the owners opened a pirate-themed pub adjoining the brewery named the Jolly Roger Taproom. Maritime Pacific's popularity steadily grew, and in 2010, it expanded, moving a few blocks south to 1111 Northwest Ballard Way. The new location includes a larger taproom and increased brewing capacity from 64 barrels a day to 160. (Paul David Gibson.)

Matt Lincecum opened Fremont Brewing Company in June 2009 after 15 years of home brewing. Fremont Brewing has a strong emphasis on community involvement and sustainability at its brewery. (Ben McAllister.)

In 2011, Fremont Brewing Company released 77 Fremont Select, a beer dedicated to Seattle's brewing past. The IPA (India Pale Ale) was created using the same fire-brewed method Horluck Brewing Co. used to create its Vienna Beer of the late 1930s. This current photograph of the brewery shows its line of brewing tanks. (Ben McAllister.)

Joel VandenBrink, founder and head brewer at Two Beers Brewing Company, established his brewery in a small Seattle garage in 2007. In 2009, he moved operations to the current location in the SoDo neighborhood, and in November 2011, the company revealed a new tasting room and expanded brewery of 4,800 square feet. In June 2011, Two Beers became the first brewery in Seattle to distribute its beer in the traditional 12-ounce can since Rainier Brewing Company in 1999.

The Elysian Brewing Company was founded in 1995 by Dick Cantwell, Joe Bisacca, and David Buhler. Cantwell had been brewing in Seattle since 1990, first at the short-lived Duwamps Café, then at Pikes Brewing Co. and Big Time Brewing Company before cofounding Elysian. The brewery currently operates three popular brewpubs in the city, and in the fall of 2011, it opened its new production brewery in Seattle's Georgetown neighborhood. This photograph from 2011 shows the company's line up of beer in its Tangletown brewpub. (Geoff Kaiser.)

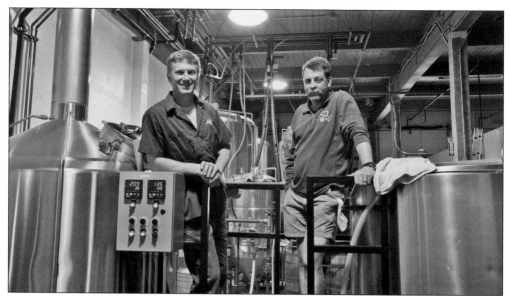

Schooner EXACT was founded in 2006 by Marcus Connery and Matt and Heather McClung. They first set up a small half-barrel brewing system in a West Seattle ActivSpace unit, selling their beer to a small number of restaurants and taverns in Seattle. As sales grew, they moved to the South Park neighborhood in 2009, then expanded to their current SoDo location the following year. This photograph shows co-owner Matt McClung (left) with brewmaster Dave Hutchinson. (Geoff Kaiser.)

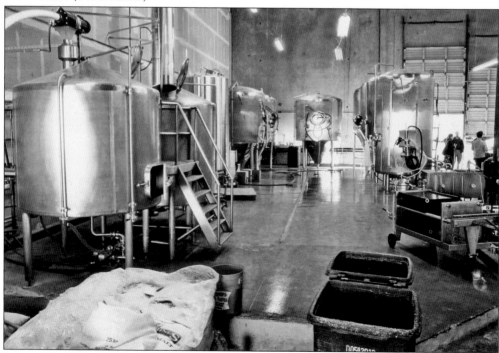

Pictured here is the Odin Brewing Company. Daniel Lee started Odin in 2010 in the South Park industrial area. Its brewmaster, Brian Taft, previously worked at the famous Guinness Brewery in Dublin, Ireland. (Russell Lo.)

Rick Hewitt leased a small part of the Rainier Brewing Company for the location of his Emerald City brewery, and upon its opening in 2010, the company became the first to brew there since Rainier ended its Seattle production in 1999. Emerald City Beer Company focuses on lager beers, and its flagship is Dottie Seattle Lager.

Full Throttle Bottles was opened in April 2008 by Erika Cowan. The beloved specialty beer and wine store is located directly across the street from the historic Seattle Brewing & Malting brewery in Georgetown and carries an impressive selection of world craft beers and ciders. Chuck's Hop Shop opened as a standard mini-market in March 2009 by Chuck Shin. As he increased his selection of craft beers, a change in state law allowed him to also install beer taps and begin in-store beer tastings. The North Seattle store has grown into one of Seattle's premiere American craft beer stores, and his selection has grown close to 1,000 bottled beers with 30 different beers on tap. (Ben McAllister.)

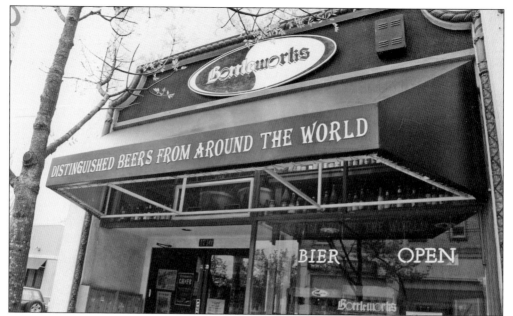

Bottleworks is one of Seattle's oldest and most respected craft beer stores. Matt Vandenberghe opened the Wallingford-area store in February 1999, and for more than a decade, he has been collaborating with some of the finest American craft brewers to release exclusive beers at his store. (Ben McAllister.)

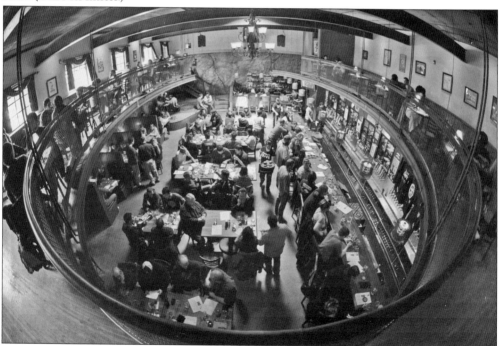

Matt Vandenberghe also opened Brouwer's Cafe in 2005 across the street from the old Redhook brewery in Fremont. Brouwer's is a mecca for Seattle beer lovers and features over 60 taps and 300 bottled beers. Various beer events throughout the year, including the annual Hard Liver Barleywine Festival, makes Brouwer's a top Seattle beer destination. (Russell Lo.)

AFTERWORD

The craft brewing movement continues to thrive. In 2011, craft beer surpassed five percent volume share of the US beer market for the very first time and was up 3.8 percent from just a few years earlier. While this number may seem minuscule compared to the brewing giants, consider during that same period total US beer sales were down an estimated 1.3 percent. Over 100,000 people are now employed in the craft brewing industry, which sold $8.7 billion of beer in 2011. In 2012, the number of operating US breweries topped 2,000 for the first time since the 1880s. This is an amazing figure, considering that only 30 years ago, the industry was at its low point of 80. For over 40 years, Rainier Brewing Company was the only brewery in Seattle. Today, that number has topped 20. After a century's worth of the massive consolidation of breweries, Seattle, along with the entire United States, is again witnessing very much the same environment its ancestors saw 130 years ago: local breweries handcrafting beer in small batches to be enjoyed on its own. Cheers!

The following are short histories of Seattle breweries not featured in the main text due to either lack of image availability or space. While none of these breweries are still active in Seattle, their contributions to the city's brewing history are not forgotten.

Pilsener Brewing Company: A short-lived Seattle brewery established by Joseph E. Fischnaller in 1933. The underfunded brewery ceased operations less than a year later, and the company was forced into bankruptcy. Part of the company moved to Ketchikan, Alaska, and operated until 1943.

Pacific Northwest Brewing Co.: An upscale Pioneer Square brewpub that was opened in 1989 by British entrepreneur Richard Wrigley and featured six cask-conditioned English-style ales on tap. The interior featured exposed brick, wooded beams, and an antique Swiss brewing pot as its centerpiece. The brewing company closed in February 1997.

The Duwamps Café/Seattle Brewing Co.: Opened a few blocks from the Space Needle in October 1990 by owners Phil Rogers and Susan Benz, Duwamps was notable in giving Dick Cantwell his first professional brewmaster gig. After the café closed in 1991, Cantrell made stops at Pike Brewing and Big Time Brewing before cofounding Elysian Brewing Co. in 1995.

Noggins Brewery, Bar & Restaurant: Owned by parent company Spinnaker's Brewery in Victoria, British Columbia, Noggins was one of the original tenants of the newly built Westlake Center in 1988. The brewery opened its second location a year later in a remodeled University District church. By July 1992, both locations were closed.

Seattle Brewers: This microbrewery was established in 1992 by Jerry Ceis. Most of its beer was served at area restaurants and bars, but it also had a small, casual onsite pub called Jerry's Jungle that served five of its ales on tap. The beers included Alki Ale, Seattle Stout, Puget Porter, and Hidden Harbor Pale. The microbrewery closed its doors in 1999.

Lunar Brewing Co.: Started by Frank Halderman in 1999 in the South Park area of Seattle, the company specialized in traditional styles of ales and lagers. In 2003, Lunar was sold and reopened as Baron Brewing Company. Frank Halderman is now the head brewer at Terminal Gravity Brewing in Enterprise, Oregon.

Moon Ales: Catherine Stombo started Moon Ales in the basement of her West Seattle home in 1998 and has the distinction of being the first commercial brewery in Seattle to be established by a woman. Moon Ales was packaged both in kegs and bottles from 1998 to 2000, and its beers included Harvest Moon Wheaten Ale and Bad Moon Bitter Ale.

Baron Brewing Co.: Mike Baker and Jeff Smiley founded the German-influenced Baron Brewing Co. in 2003 after purchasing Lunar Brewing Co. In 2011, owner Jeff Smiley moved his brewing operations to Chehalis, Washington.

Discover Thousands of Local History Books Featuring Millions of Vintage Images

Arcadia Publishing, the leading local history publisher in the United States, is committed to making history accessible and meaningful through publishing books that celebrate and preserve the heritage of America's people and places.

Find more books like this at
www.arcadiapublishing.com

Search for your hometown history, your old stomping grounds, and even your favorite sports team.